As They Were

As They Were

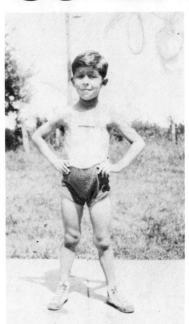 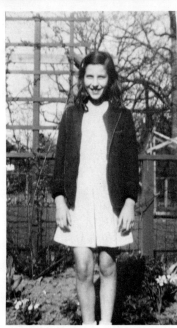

Tuli Kupferberg & Sylvia Topp

New York
London

Published by Links Books
33 West 60 Street, New York 10023 and
78 Newman Street, London W.1

First printing
Standard Book Number: 0-8256-3008-8
Library of Congress Catalog Card Number: 72-94089
Printed in the United States of America

Book and cover design by Holly McNeely

At a gallop we charge up the shingle,
At a gallop we leap the sea wall,
With a mad exultation we tingle,
For we, we can overcome all.

Aldous Huxley, age 13

Bella Abzug
(age 5)

born July 20, 1920, in the Bronx, N.Y.

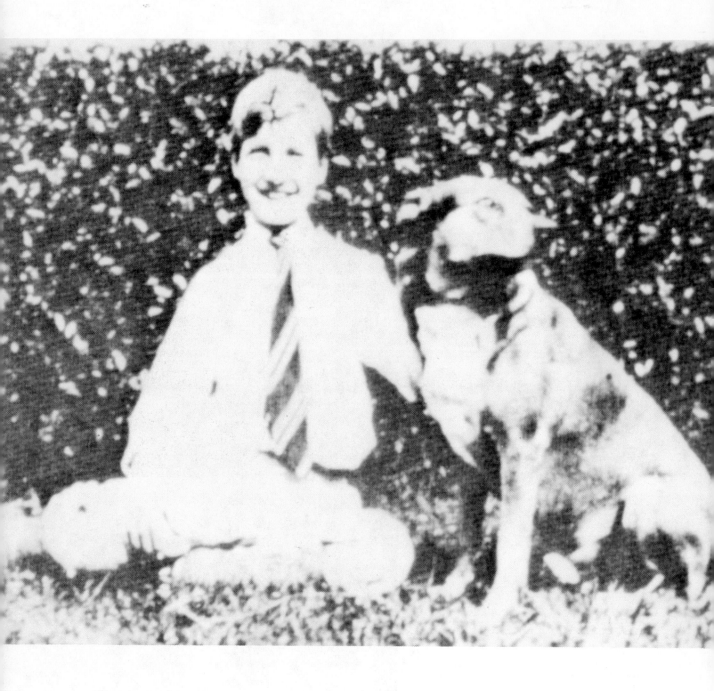

Spiro Agnew

born Nov. 9, 1918, in Baltimore, Md.

This lexicon, compiled by Sholom Aleichem before he was 15, can be considered his first work.

It is a list of all the curse words his new stepmother addressed him with, which he tastefully and alphabetically arranged for the convenience of the reader.

STEPMOTHER'S VOCABULARY

A—Annoyance, ape, apostate, apple-thief, ass.
B—Bare-bottom, barker, beast, bedbug, beggar, belly-ache, belly-button, blinker, blockhead, bone-in-the-throat, boor, botcher, bottomless-gullet, brother-in-sorrow, bully, butcher.
C—Cake-and-honey, cap, carcass, cattle, cheat, cheeky, clown, cockroach, convert, cow, crazy, creature, cripple, cry-baby.
D—Dandy, devil, dirty-mouth, dog-catcher, donkey, don't-touch-me.
E—Ear-ache, eel, effigy, egg, empty-barrel.
F—Fiend, fool, foundling, frog.
G—Gambler, garbage, glutton, good-for-nothing, greedy.
H—Half-wit, Haman, hash, hen, heretic, hog, holy-seed, hoodlum, hump.
I—Idiot, image, imp, infidel, ingrate, ink-blot, innocent lamb, insect.
J—Jackal, jackass, jail-bird, Joseph-the-Righteous, junk.
K—Knock-on-wood, know-it-all.
L—Lazy-bones, leech, liar, lick-plate, locust, log, louse.
M—Melon, midget, mongrel, monkey, misery, mud, mule.
N—Nanny-goat, ninny, nobody, noodle, nuisance.
O—Onion, open-your-mouth, outcast, owl, ox.
P—Pancake, pen-and-ink, pepper, pest, pig, poison, precious, puppy.
Q—Quack, quince.
R—Rag, rat, raw-potato, riff-raff, rogue, rowdy, ruffian.
S—Sabbath-Goy, saint, sausage, scholar, scribbler,

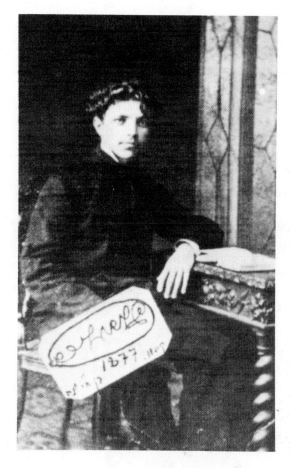

scum, slob, slops, smirker, snake, sneak, snout, soak, spy, squirrel, stiffnecked-people, sucker, sweet-tooth, swine.
T—Tattle-tale, thick-head, thief, thunder-and-lightning, toad, tomcat, toothache, tramp, trousers-owner, turkey, turtle.
U—Ugly, ulcer, useless.
V—Villain, vinegar, viper.
W—Wax-in-the-ears, whelp, worm, wretch.
Y—Yellow, yelper.
Z—Zany, zealot, zero.

Sholom Aleichem
(age 18)

born Feb. 18, 1859, in Pereyaslavl, Ukraine

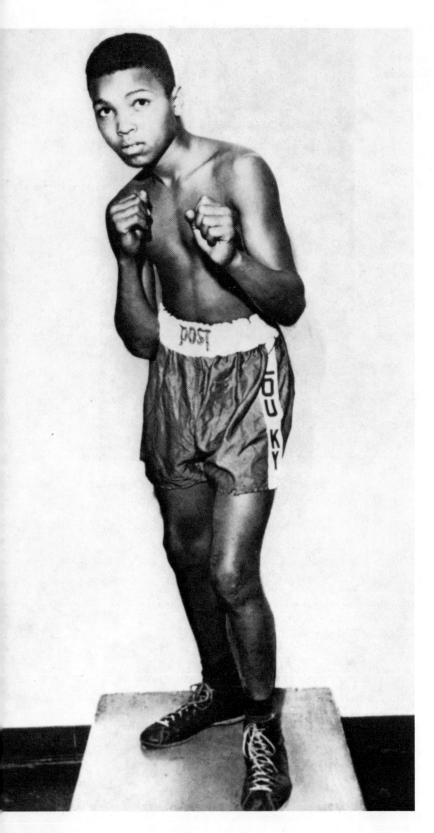

Muhammad Ali
(age 12)

born Jan. 18, 1942, in Louisville, Ky.

Steve Allen
(age 2½)

born Dec. 26, 1921, in New York City

Jack Anderson

born Oct. 19, 1922, in Long Beach, Calif.

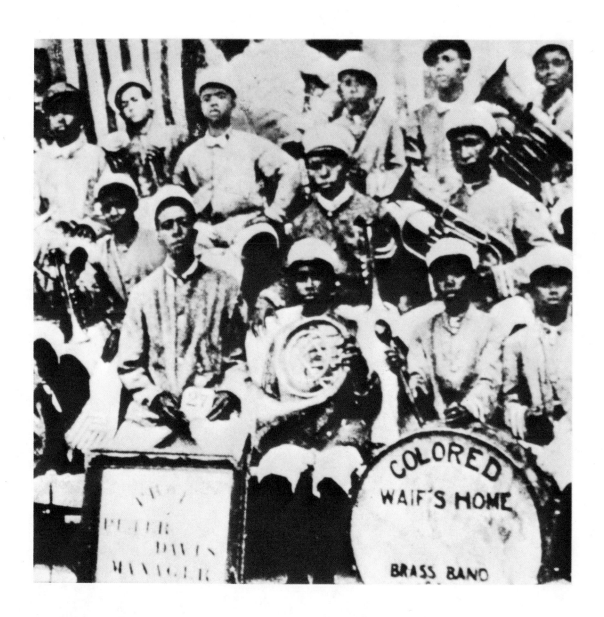

Louis Armstrong
(top row, third from left, age 10)

born July 4, 1900, in New Orleans, La.

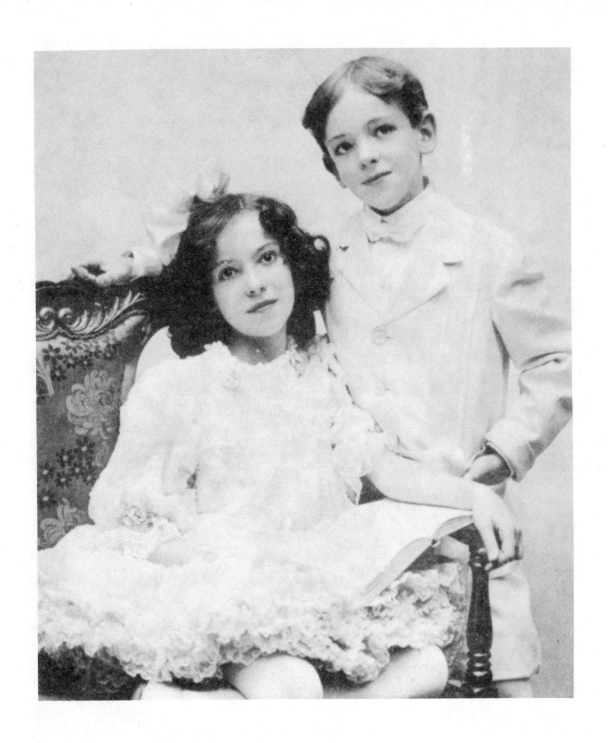

Fred Astaire
(age 10) with his sister Adele
born May 10, 1899, in Omaha, Neb.

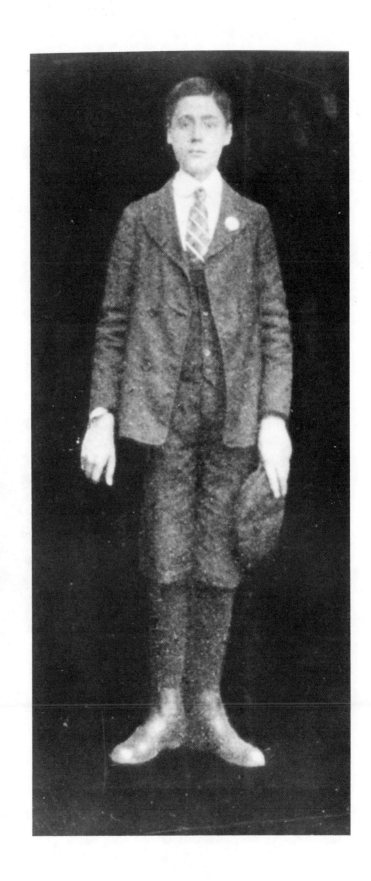

Charles Atlas
(age 15)

born Oct. 30, 1893,
in Acri, southern Italy

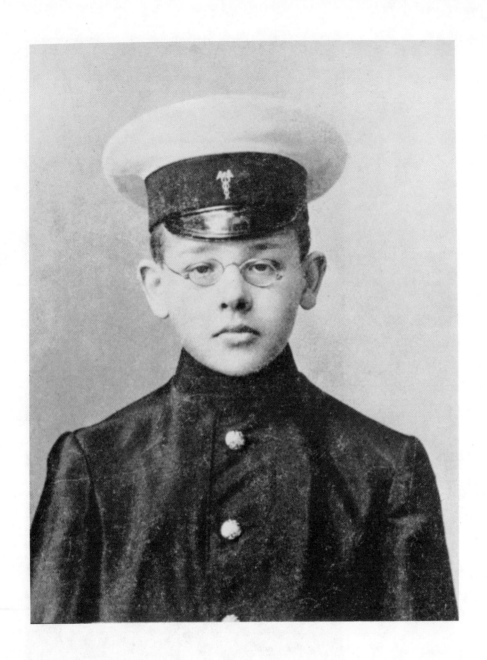

Isaak Babel

born July 13, 1894, in Odessa, Russia

Joan Baez

born Jan. 9, 1941, on Staten Island, N.Y.

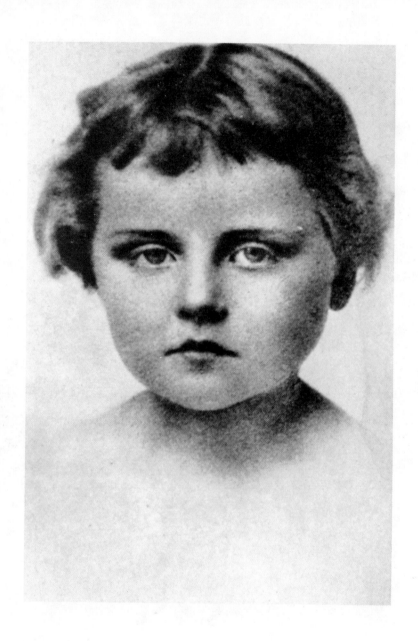

Tallulah Bankhead
(age 4)

born Jan. 31, 1903, in Huntsville, Ala.

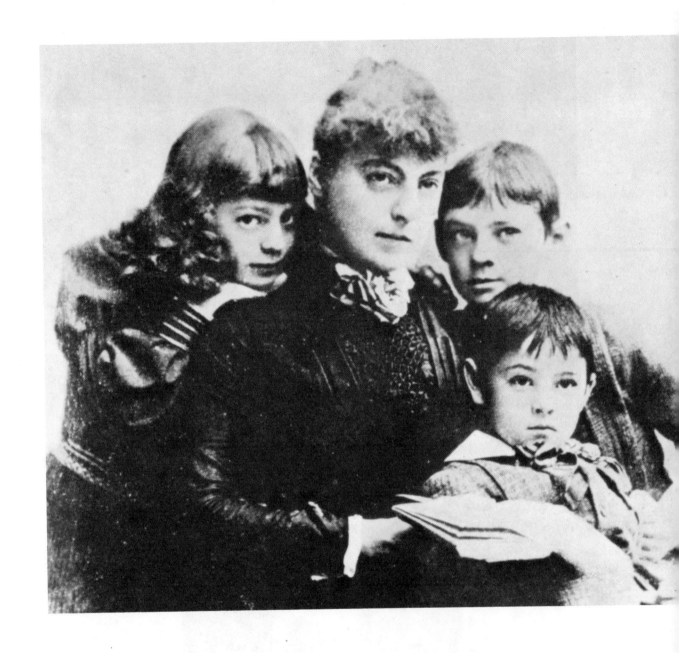

Ethel, Lionel, and John Barrymore

with their mother

Lionel: born April 28, 1878, in Philadelphia, Pa.
Ethel: born Aug. 15, 1879, in Philadelphia, Pa.
John: born Feb. 15, 1882, in Philadelphia, Pa.

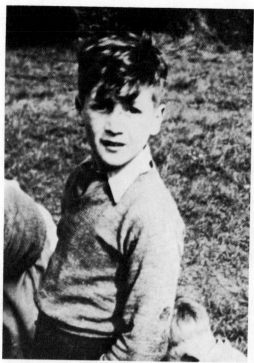

John Lennon: born Oct. 9, 1940,
in Liverpool, England

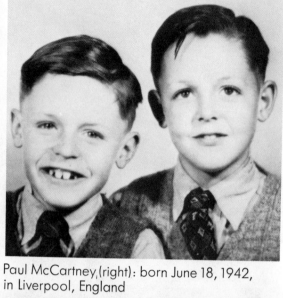

Paul McCartney (right): born June 18, 1942,
in Liverpool, England

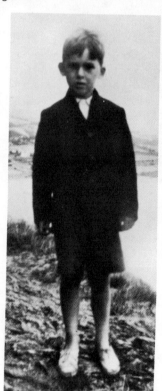

Ringo Starr: born July 7, 1940,
in Liverpool, England

The Beatles

George Harrison: born Feb. 25, 1943,
in Liverpool, England

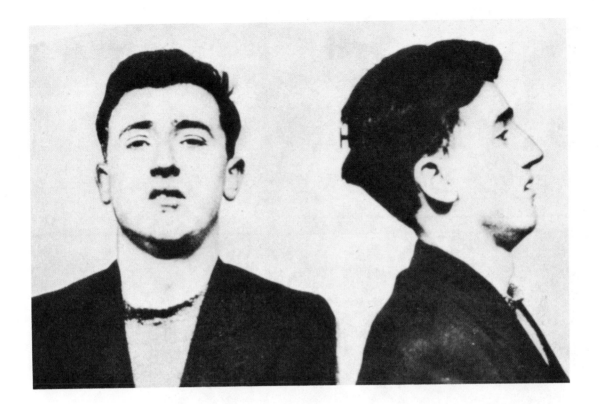

Brendan Behan

(about 19) arrest photo, 1942
born Feb. 9, 1923, in Dublin, Ireland

I think you were awfully decent
Not to give my name.
Not even to your Da or Ma,
But shouldered all the blame.

Oh, what can I do now, love,
To restore our happiness?
Will I go across to Gill's pub
And to your Ma confess?

Actually, Teresa,
I've just got two and six
So will you stop sulking in the parlour
And go with me to the flicks?

Teresa I am sorry
If I got you bashed in school.
It was a stupid thing to do
And I feel an awful fool.

I was really raging
When I heard you went to the pics
With, of all the eejits,
Snotty-nosed Paddy Fitz.

I'll take you to the Drummer
To the ninepenny cushion seats,
And that will leave me with a bob
To get you oranges and sweets.

To give this its proper ending
I'll wind up with yours for ever, Brendan.

(age 9)

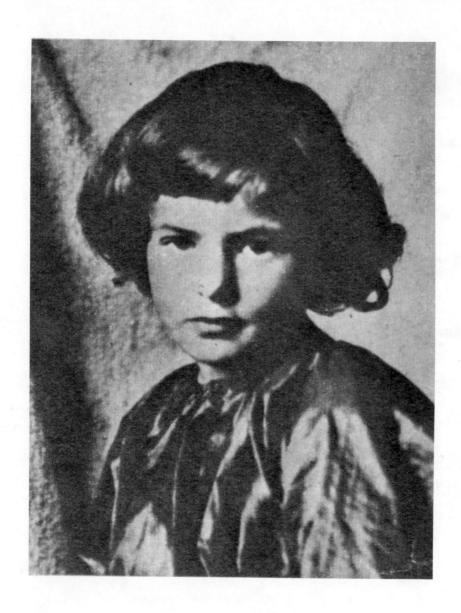

Ingrid Bergman
(age 8)

born Aug. 29, 1915, in Stockholm, Sweden

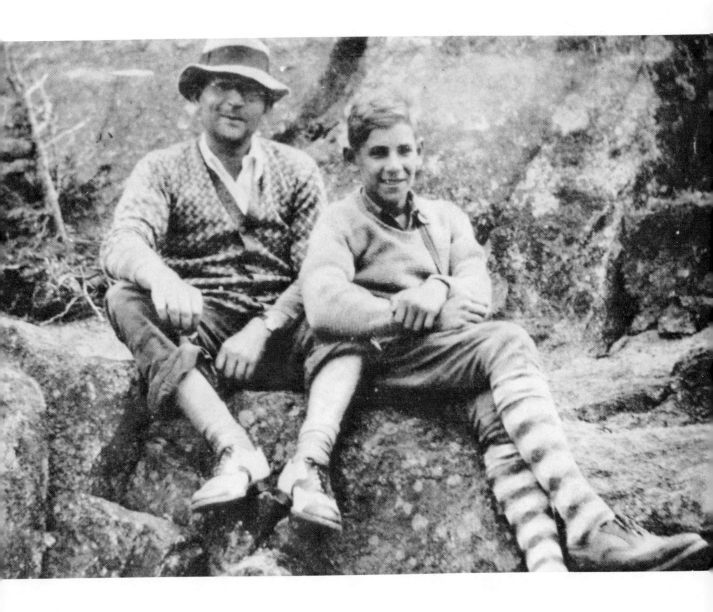

Leonard Bernstein
(age 11) with his father

born Aug. 25, 1918, in Lawrence, Mass.

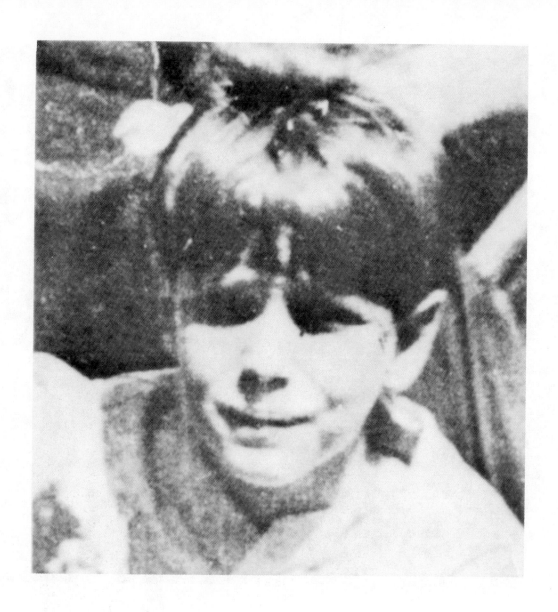

Humphrey Bogart
(age 8)

born Dec. 25, 1899, in New York City

Willy Brandt

born Dec. 18, 1913,
in Lübeck, Germany

Bertolt Brecht
(left, about 4) with his brother Walter

born Feb. 10, 1898, in Augsburg, Germany

Lenny Bruce
(second row from top, left) with North Bellmore classmates

born 1926, in Mineola, L.I., N.Y.

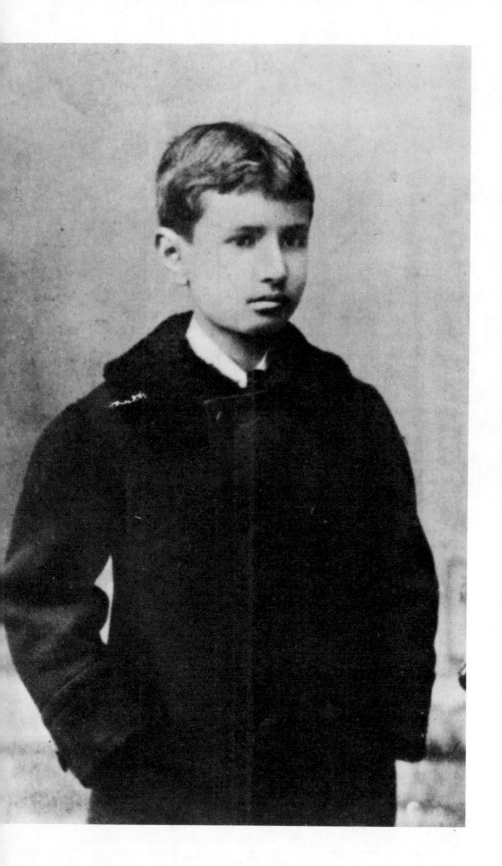

Martin Buber

born Feb. 8, 1878,
in Vienna

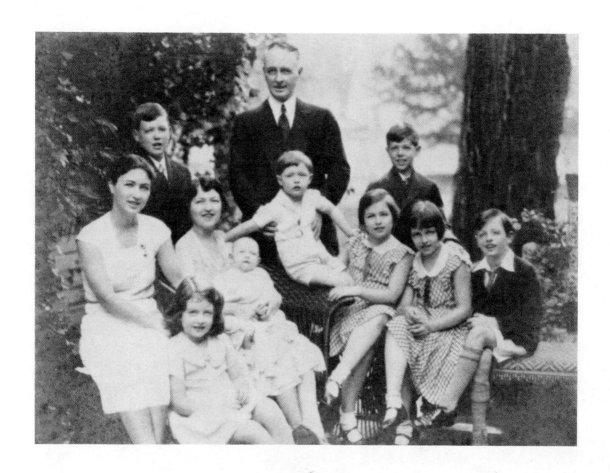

William and James Buckley

(William, right, age 7) (James, third from right, age 10) with their family

James: born March 9, 1923, in New York City
William: born Nov. 24, 1925, in New York City

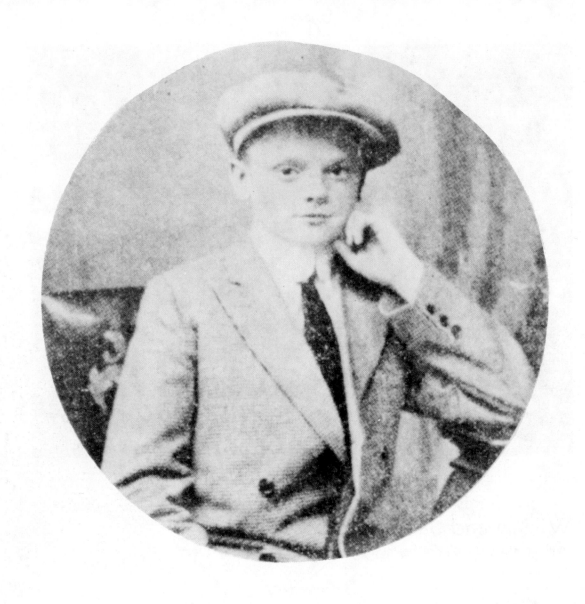

James Cagney
(age 10)

born July 17, 1899, in New York City

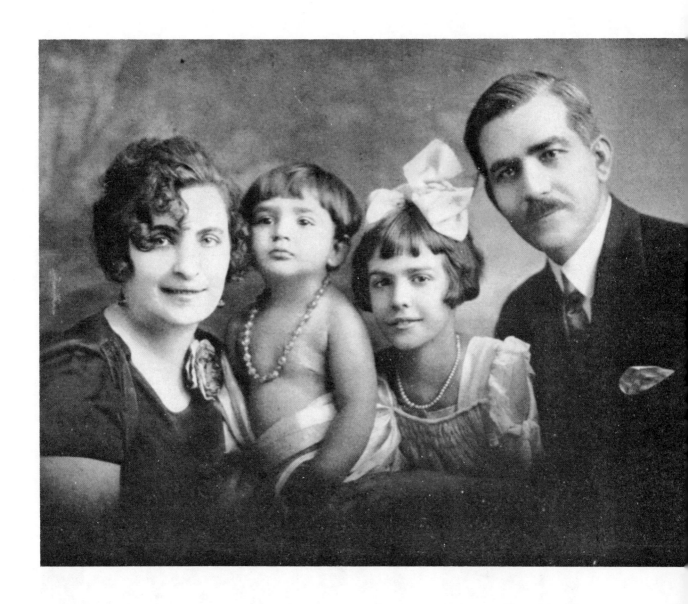

Maria Callas
(age 1) with her family

born Dec. 2, 1923, in New York City

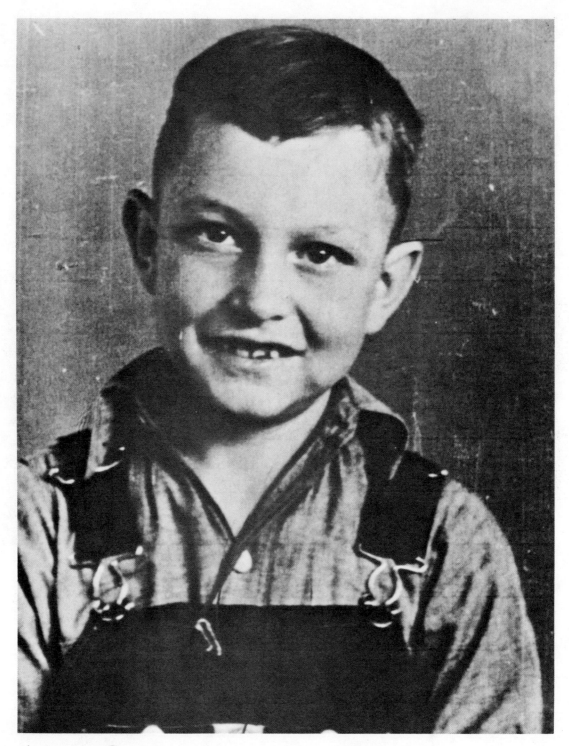

Johnny Cash

born Feb. 26, 1932, in Kingsland, Ark.

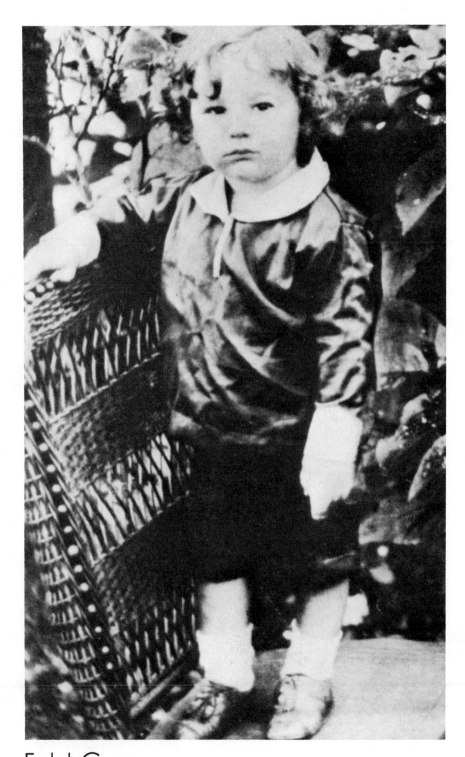

Fidel Castro
(age 3)
born Aug. 13, 1927, in Mayari, Oriente Province, Cuba

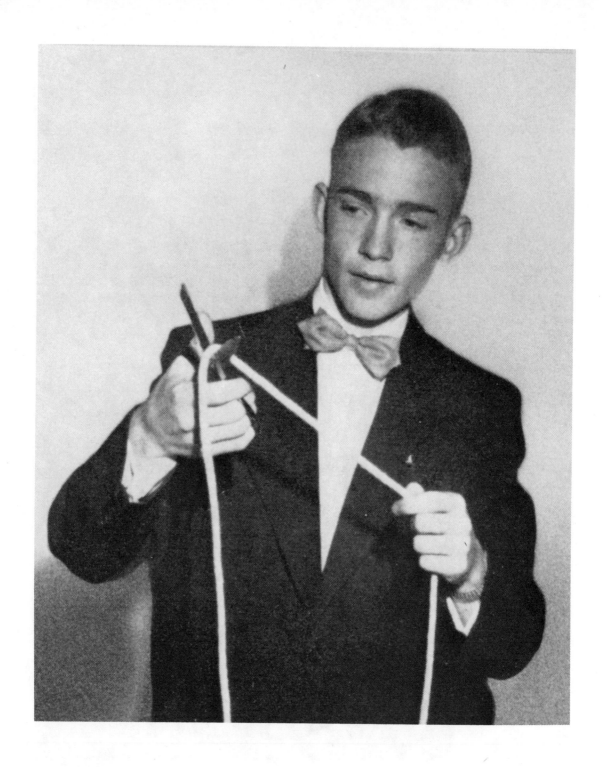

Dick Cavett

born Nov. 19, 1936, in Gibbon, Neb.

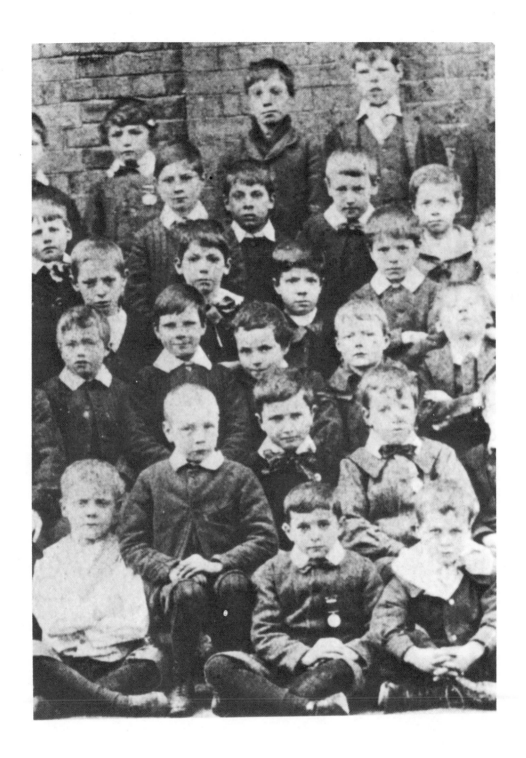

Charlie Chaplin
(fourth row from top, center, age 7 ½) at school in Kennington
born April 16, 1889, in London, England

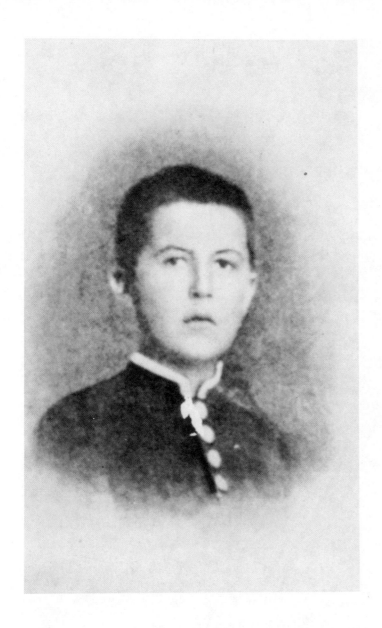

Anton Chekhov
(age 14)

born Jan. 17, 1860, in Taganrog, Russia

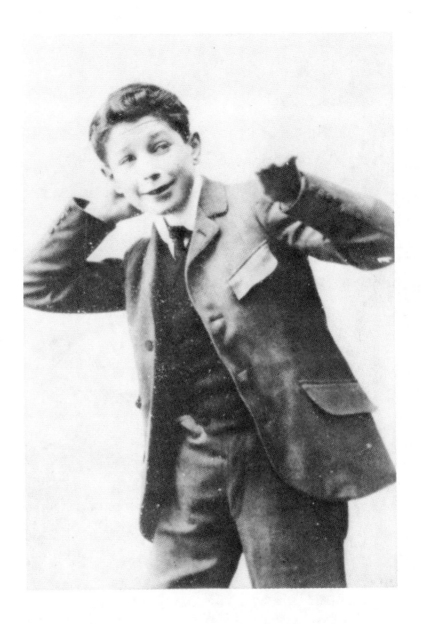

Maurice Chevalier

born Sept. 12, 1888, in Paris, France

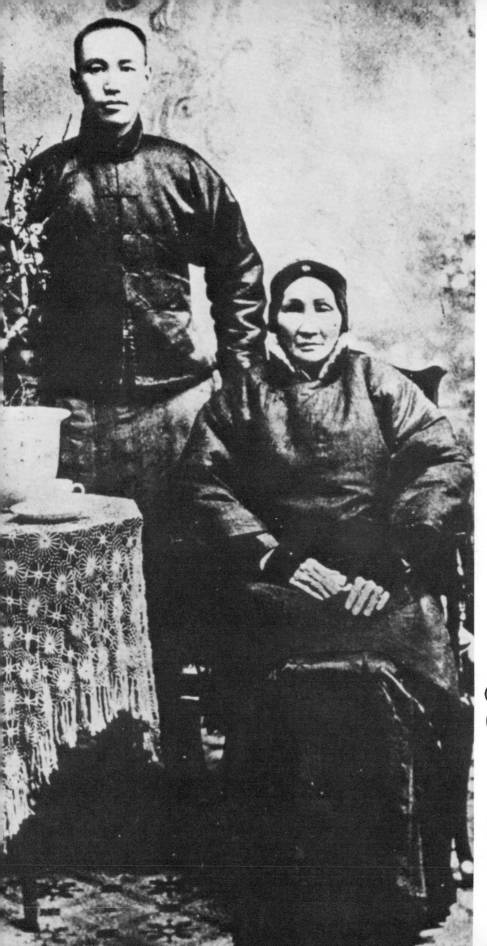

Chiang Kai-shek
(about 17) with his mother

born Oct. 31, 1887,
in Fenghua,
Chekiang Province, China

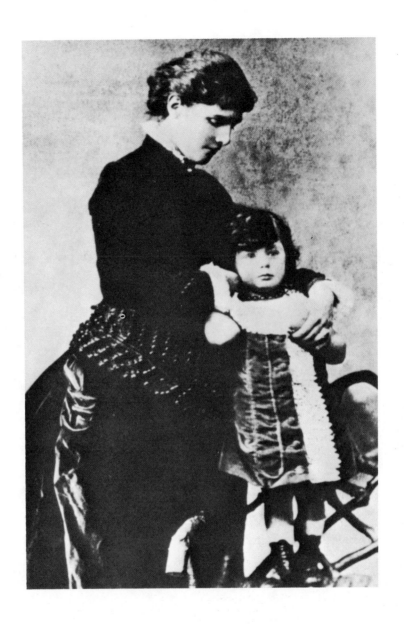

Winston Churchill
(about 2) with his mother

born Nov. 30, 1874, in Blenheim Palace,
near Woodstock, Oxfordshire, England

Judy Collins
(age 11)

born May 1, 1939, in Seattle, Wash.

Noel Coward
(age 2)

born Dec. 16, 1899, in London, England

Walter Cronkite

born Nov. 4, 1916,
in St. Joseph, Mo.

Richard Daley
as an altar boy

born May 15, 1902, in Chicago, Ill.

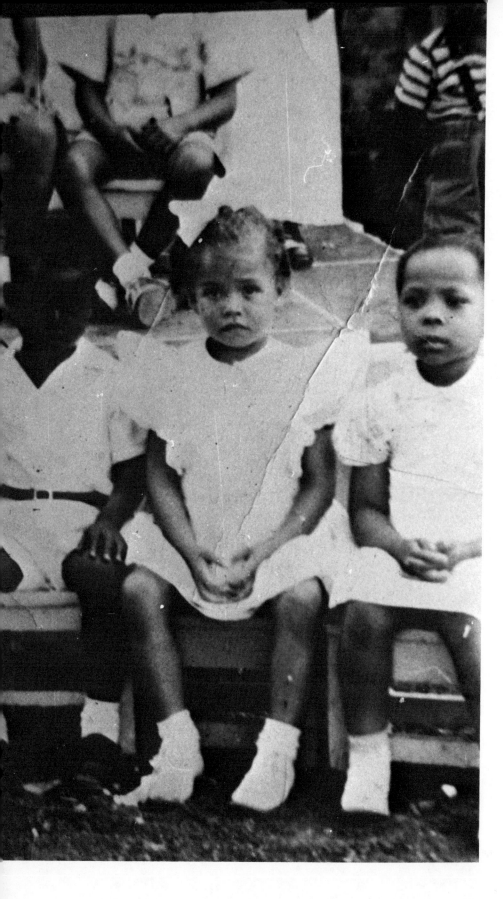

Angela Davis
(center)

born Jan. 26, 1944,
in Birmingham, Ala.

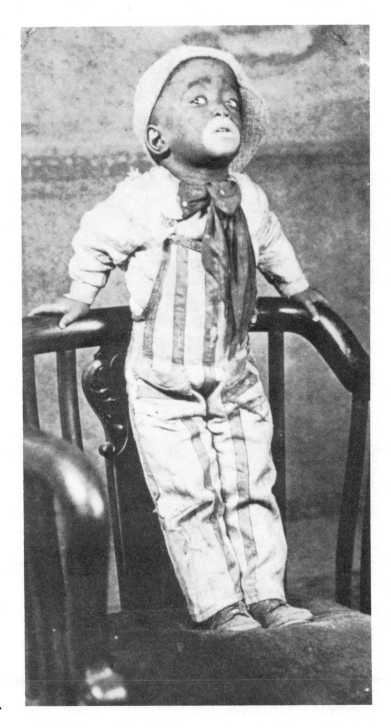

Sammy Davis, Jr.
(about 3)

born Dec. 8, 1925,
in New York City

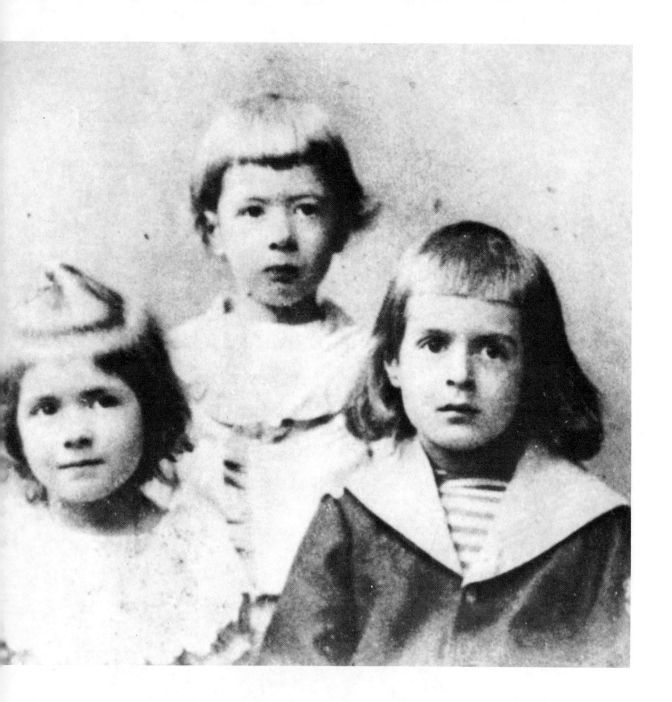

Charles de Gaulle

(center, age 7) with his sister Marie Agnès and his brother Xavier

born Nov. 22, 1890, in Lille, France

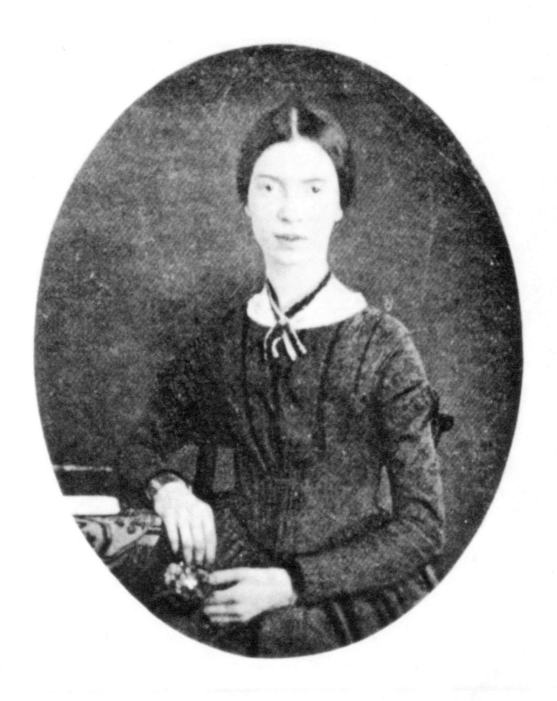

Emily Dickinson
(about 17)

born Dec. 10, 1830, in Amherst, Mass.

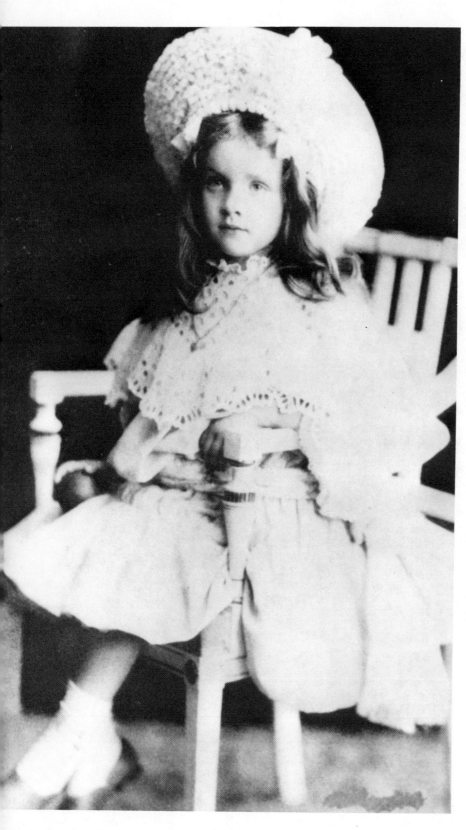

Marlene Dietrich

born Dec. 27, 1904,
in Berlin, Germany

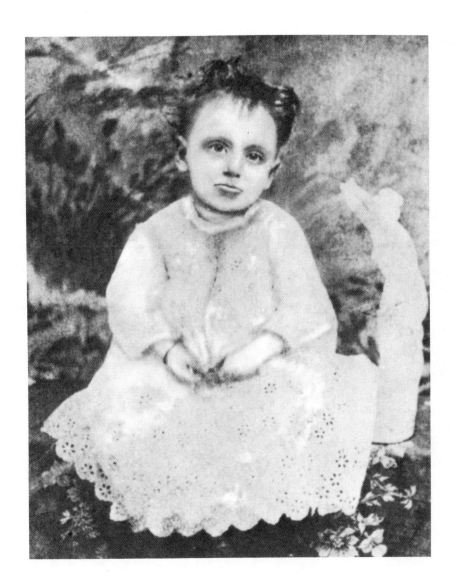

Jimmy Durante

born Feb. 10, 1893, in New York City

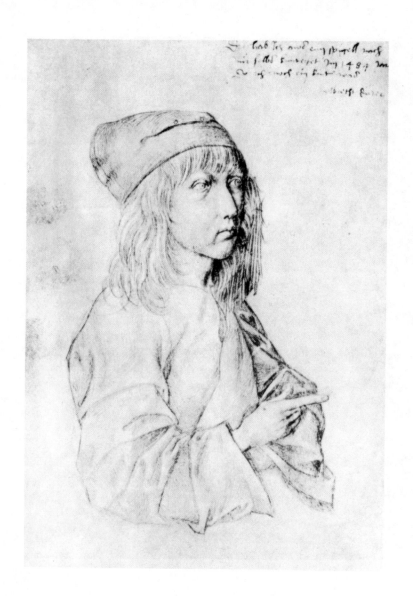

Albrecht Dürer

(about 13) self-portrait

born May 21, 1471, in Nuremberg, Germany

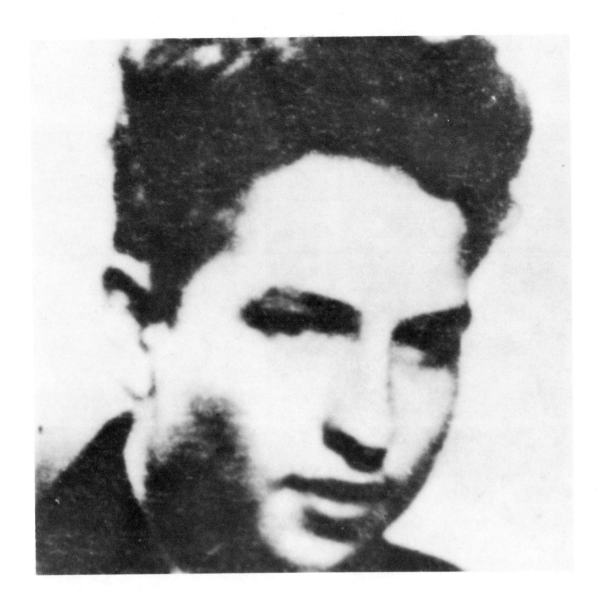

Bob Dylan
high school yearbook

born May 24, 1941, in Duluth, Minn.

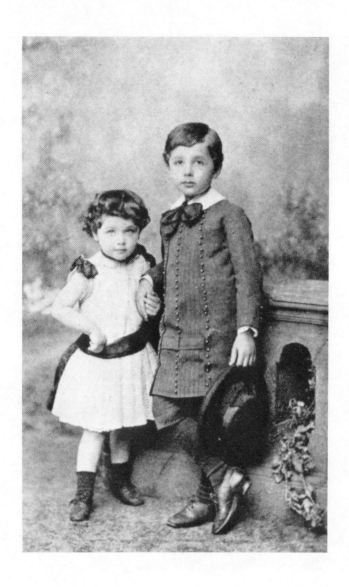

Albert Einstein
(about 6) with his sister Maja

born March 14, 1879, in Ulm, Bavaria

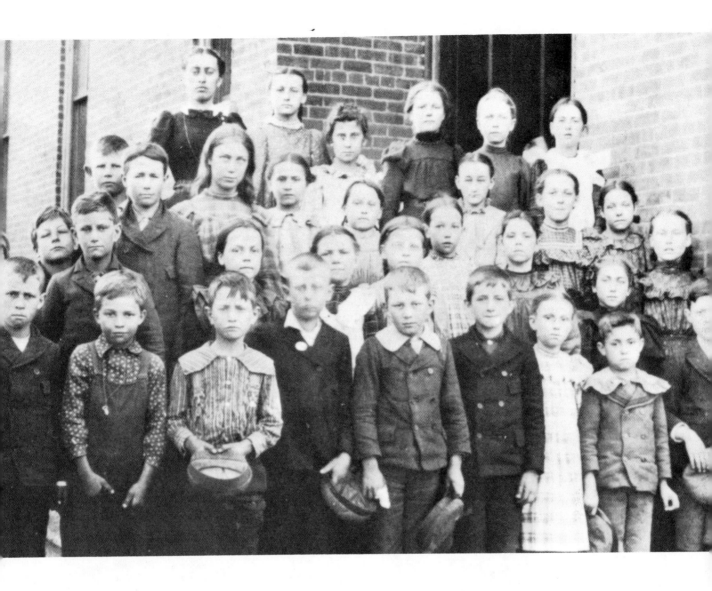

Dwight D. Eisenhower

(front row, second from left) with fourth-grade classmates in Abilene, Texas (notice the key around his neck)

born Oct. 14, 1890, in Denison, Texas

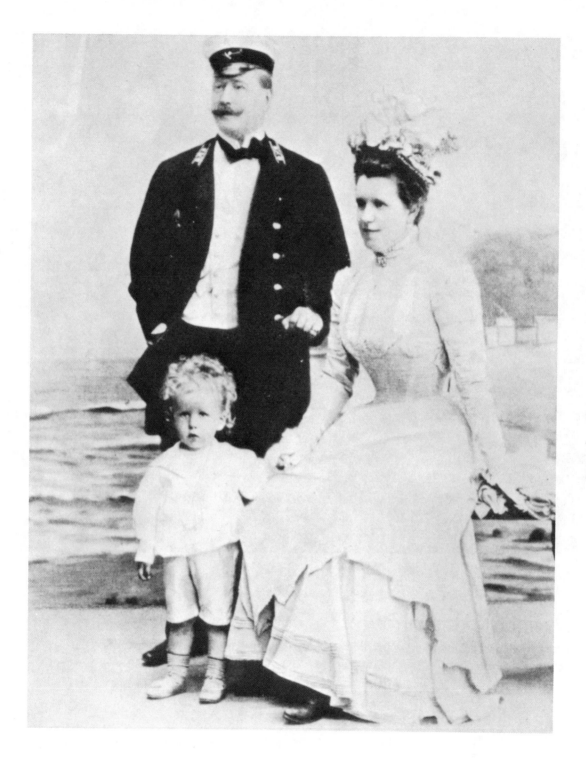

Sergei Eisenstein
(about 2) with his parents
born Jan. 23, 1898, in Riga, Latvia

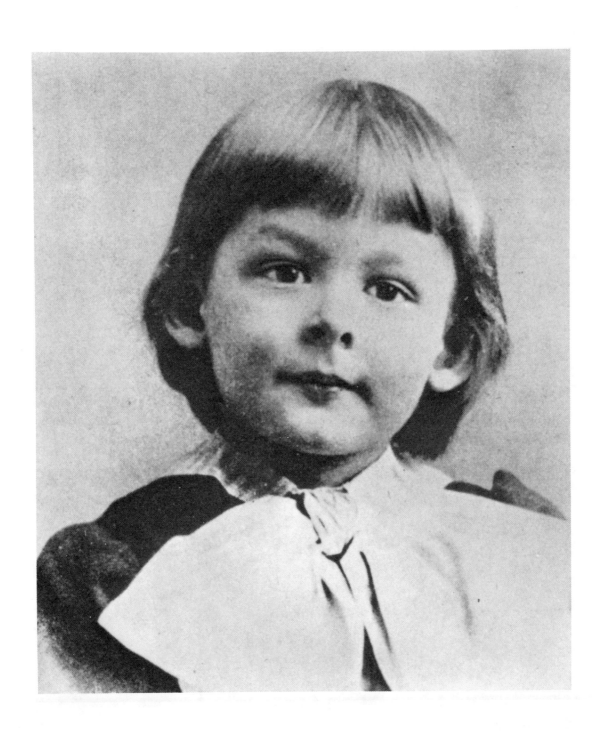

T. S. Eliot
(age 3)
born Sept. 26, 1888, in St. Louis, Mo.

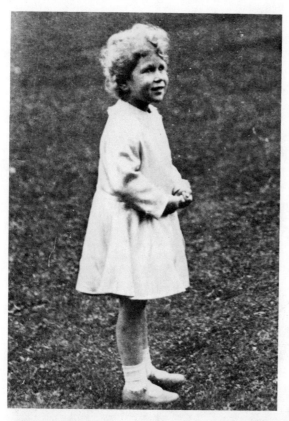

Queen Elizabeth II
born April 21, 1926, in London, England

Prince Philip
(second from left)
born June 10, 1921, in Corfu, Greece

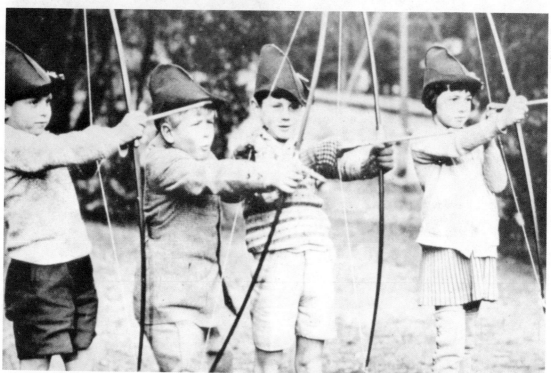

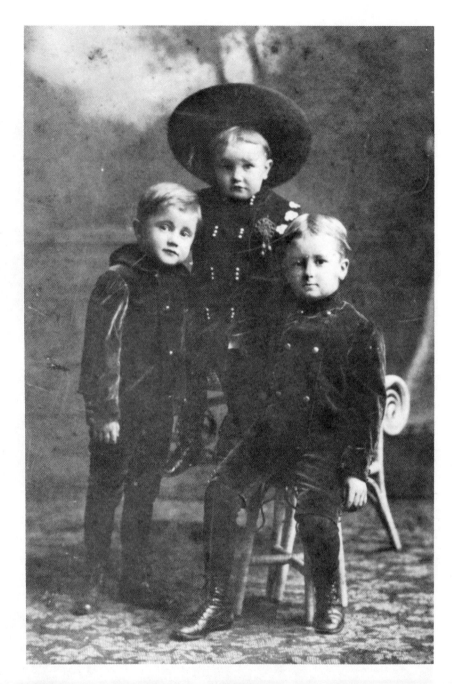

William Faulkner
(right) with his brothers Jack and John

born Sept. 25, 1897, in New Albany, Miss.

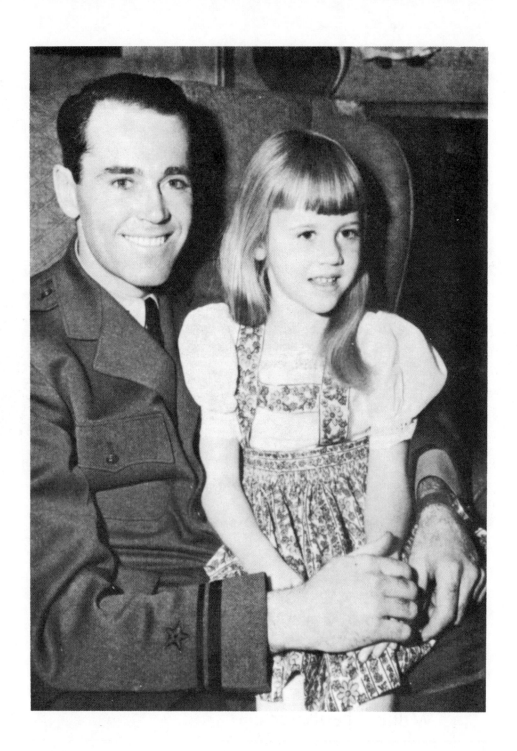

Jane Fonda
with her father Henry
born Dec. 21, 1937, in New York City

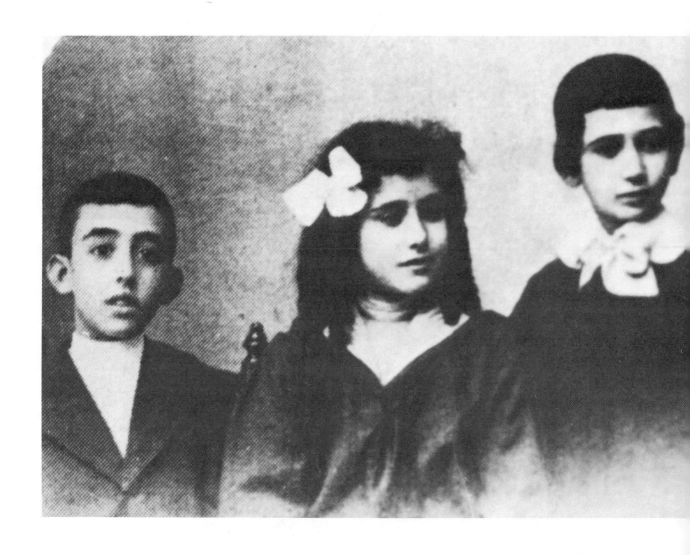

Francisco Franco

(left) with his sister Pilar and brother Nicolás

born Dec. 4, 1892, in El Ferrol, Province of Corunna, Spain

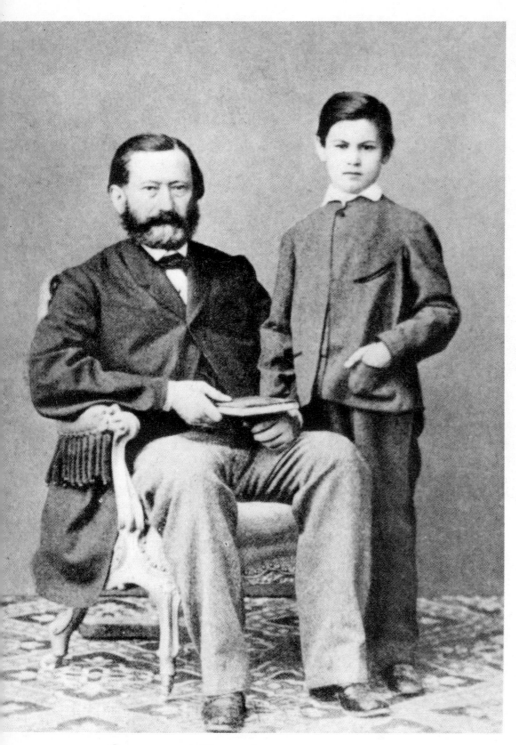

Sigmund Freud
(age 8) with his father
born May 6, 1856, in Freiberg, Moravia

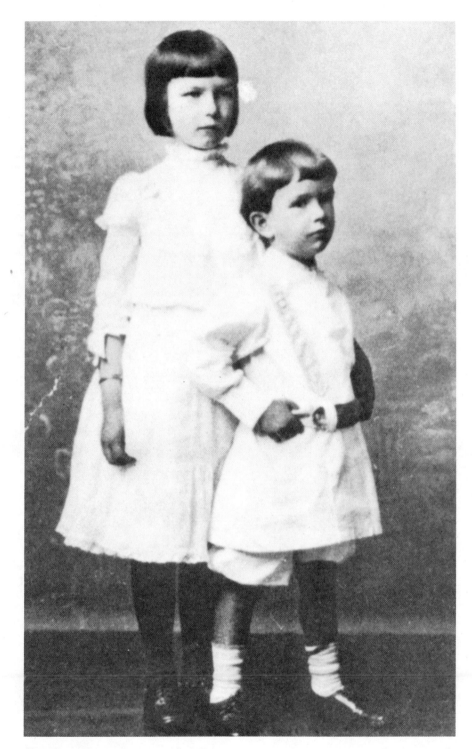

R. Buckminster Fuller
(age 4) with his sister Lesley
born July 12, 1895, in Milton, Mass.

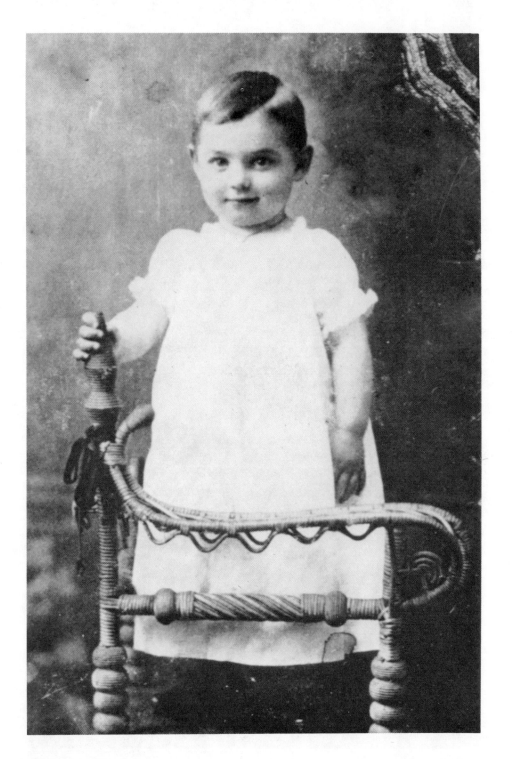

Clark Gable
(age 16 months)
born Feb. 1, 1901, in Cadiz, Ohio

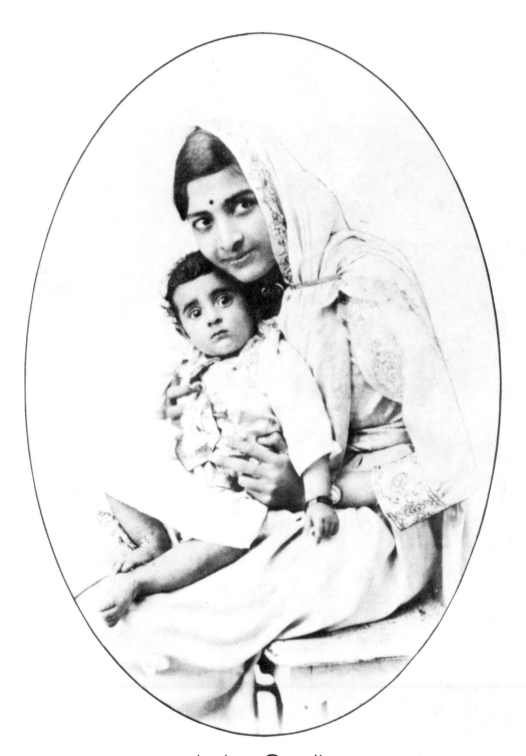

Indira Gandhi
with her mother
born Nov. 19, 1917, in Allahabad, India

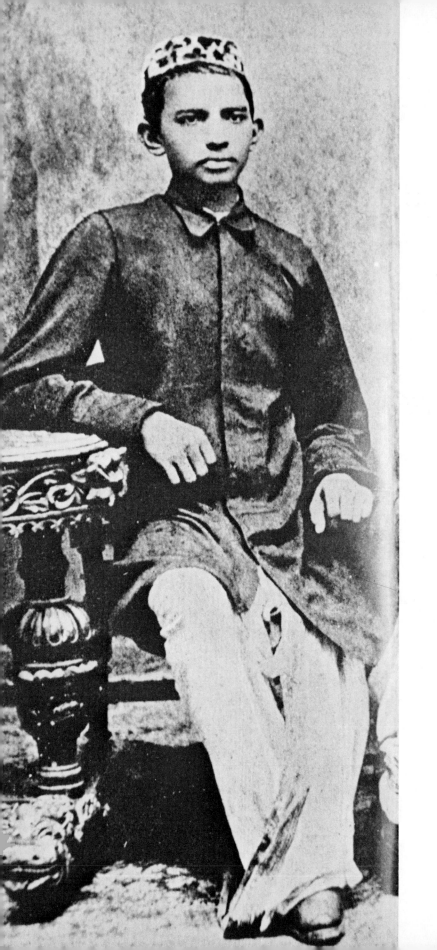

Mohandas Gandhi
(age 14) born Oct. 2, 1869,
in Porbandar, Kathiawad, India

Greta Garbo

on day of her first Communion
born Sept. 18, 1905, in Stockholm, Sweden

Allen Ginsberg
with his mother, born June 3, 1926, in Newark, N.J.

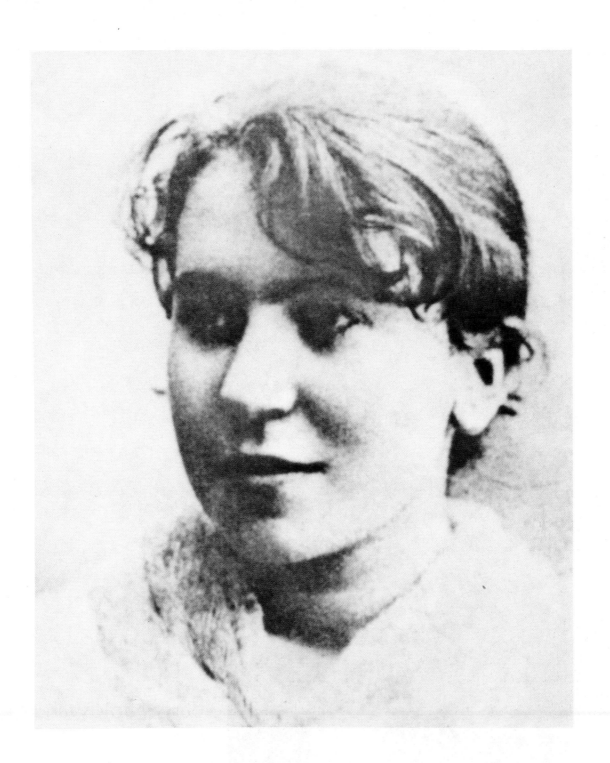

Emma Goldman
(about 17) born June 27, 1869, in Kovno, Lithuania

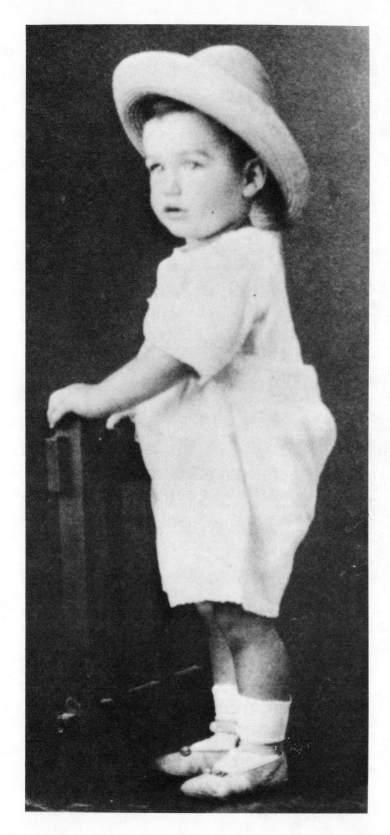

Barry Goldwater
(age 3)

born Jan. 1, 1909,
in Phoenix, Ariz.

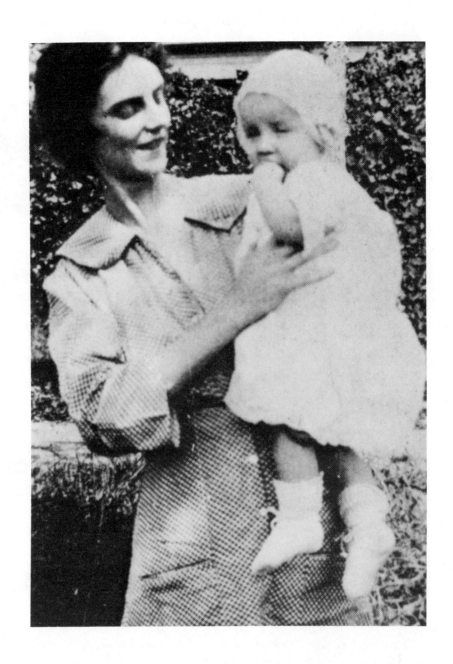

Billy Graham
(age 6 months) with his mother

born Nov. 7, 1918, on a farm near Charlotte, N.C.

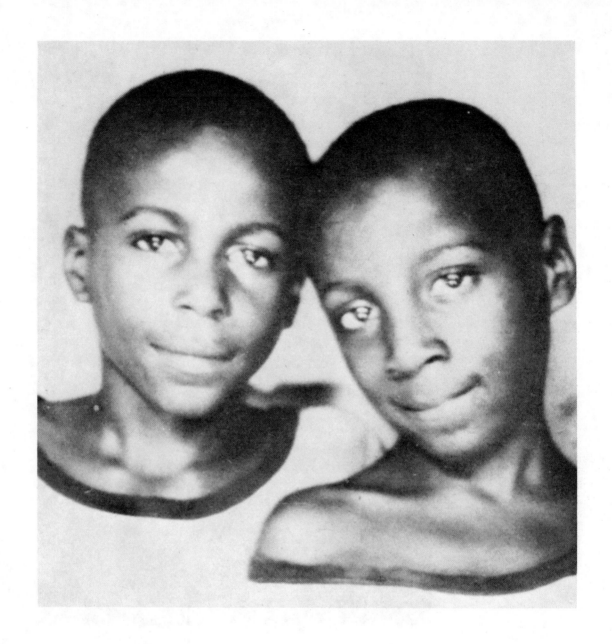

Dick Gregory

(right, about 10) with his brother Presley

born Oct. 12, 1932, in St. Louis, Mo.

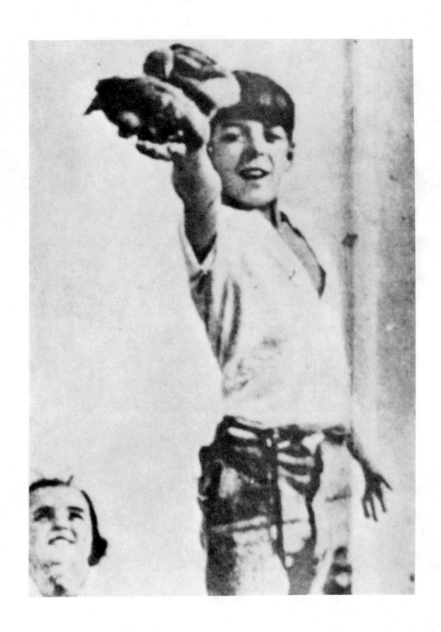

Ché Guevara
(age 10) with his sister Ana María

born June 14, 1928, in Rosario, Argentina

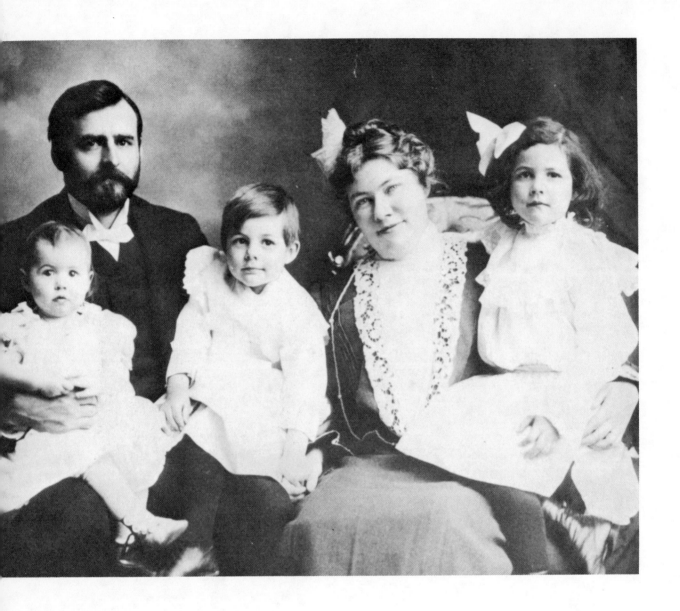

Ernest Hemingway
(center, age 4) with some of his family

born July 21, 1899, in Oak Park, Ill.

Hermann Hesse
(age 4)

born July 2, 1877, in Calw, Württemberg, Germany

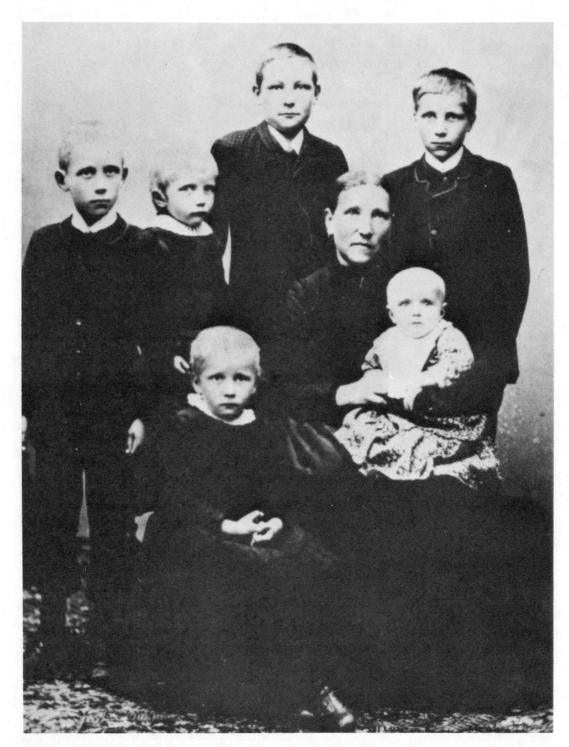

Joe Hill
(left) with his family
born Oct. 7, 1879, in Gävle, Sweden

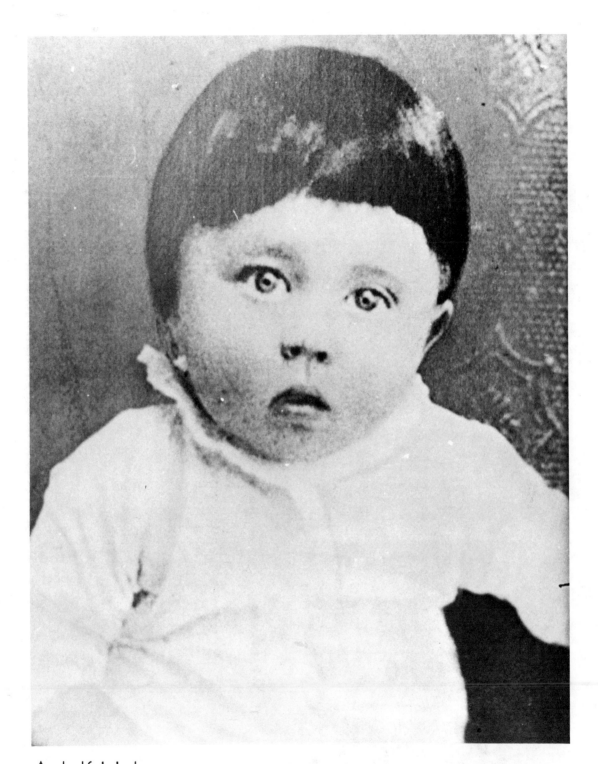

Adolf Hitler

born April 20, 1889, in Branau, Upper Austria

Abbie Hoffman
(about 6)

born Nov. 30, 1936,
in Worcester, Mass.

J. Edgar Hoover
(age 4)

born Jan. 1, 1895,
in Washington, D.C.

Hubert Humphrey
(age 3)

born May 27, 1911, in Wallace, S.D.

Aldous Huxley
(age 8)

born July 26, 1894,
in Godalming,
Surrey, England

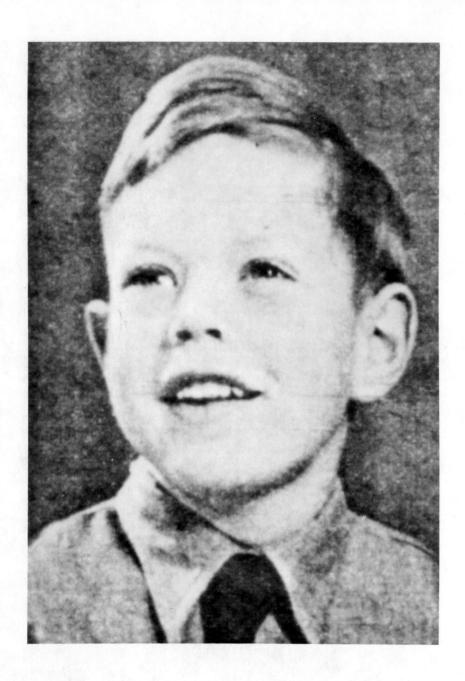

Mick Jagger

born July 26, 1944, in Dartford, Kent, England

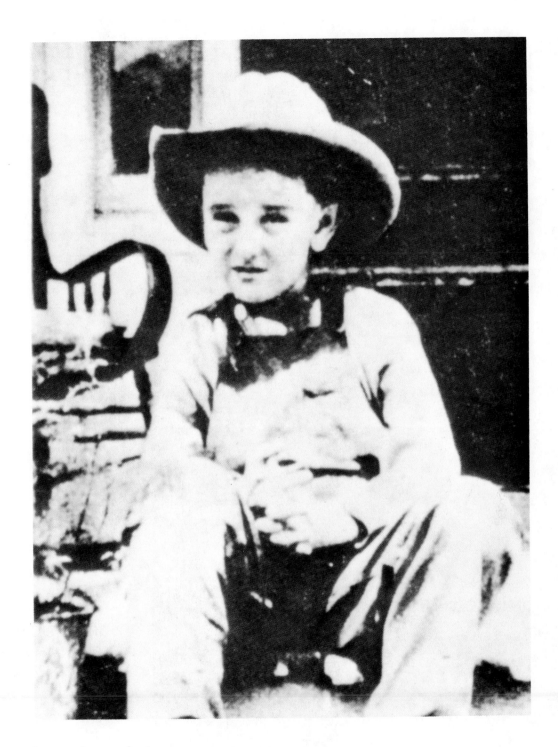

Lyndon Johnson
(age 4)

born Aug. 27, 1908, near Stonewall, Texas

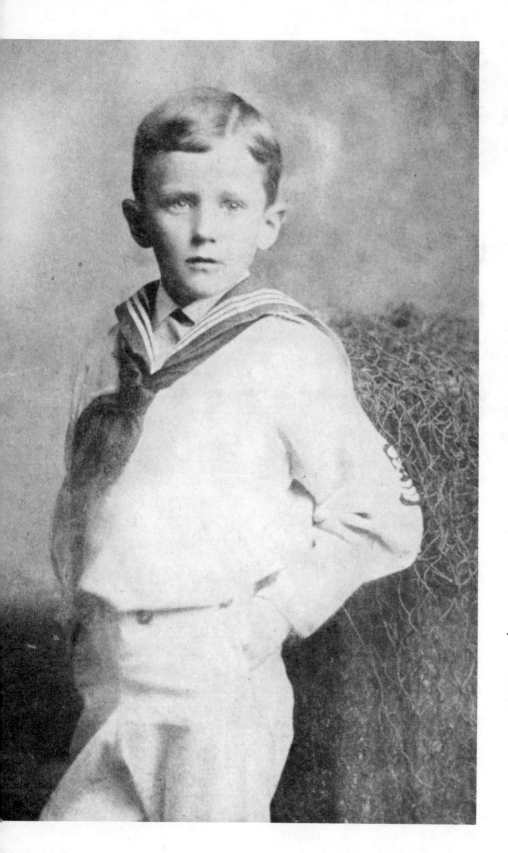

James Joyce
at Clongowes Wood
College (1888-1891)

born Feb. 2, 1882,
in Dublin, Ireland

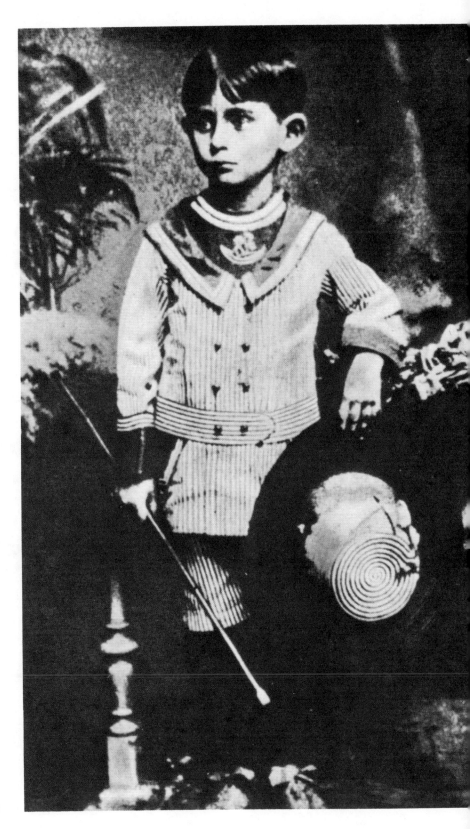

Franz Kafka
(about 5)

born July 3, 1883, in Prague

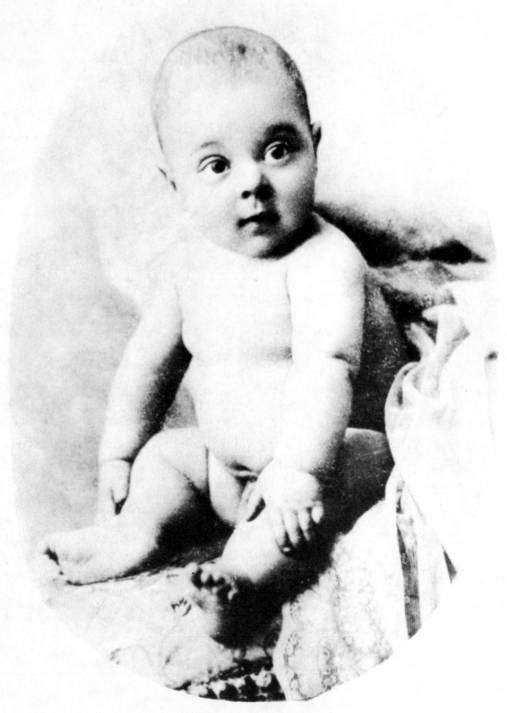

Buster Keaton
(age 1)
born Oct. 4, 1896, in Pickway, Kansas

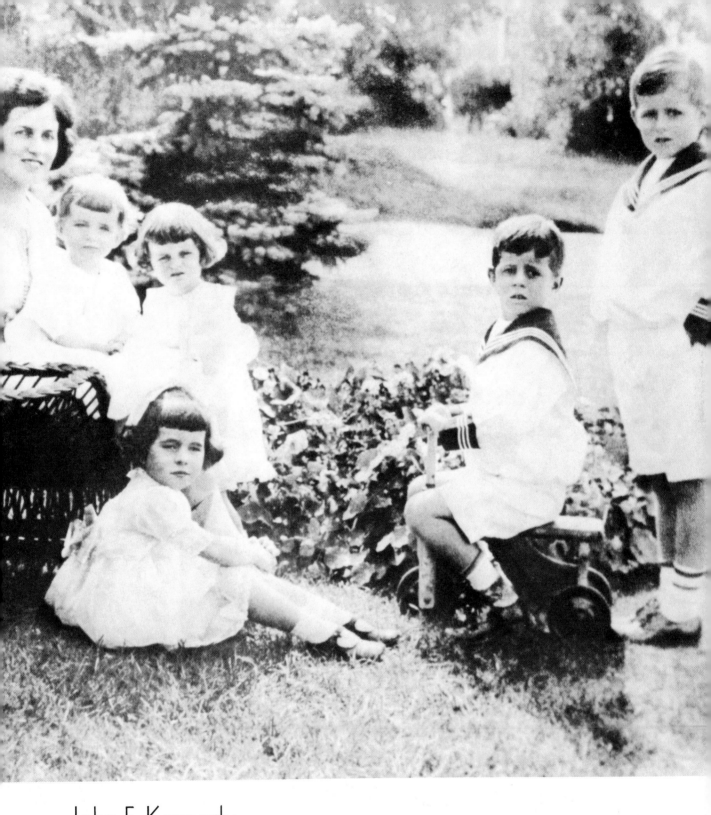

John F. Kennedy
(second from right) with his mother, Eunice, Kathleen, Rosemary, and Joe, Jr.
born May 29, 1917, in Brookline, Mass.

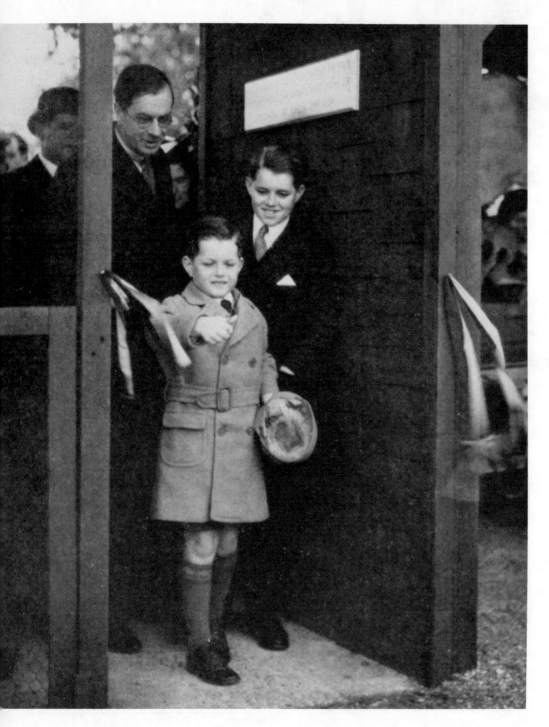

Edward and Robert Kennedy
at opening of Children's Zoo in London
Robert: born Nov. 20, 1925, in Boston, Mass.
Edward: born Feb. 22, 1932, in Boston, Mass.

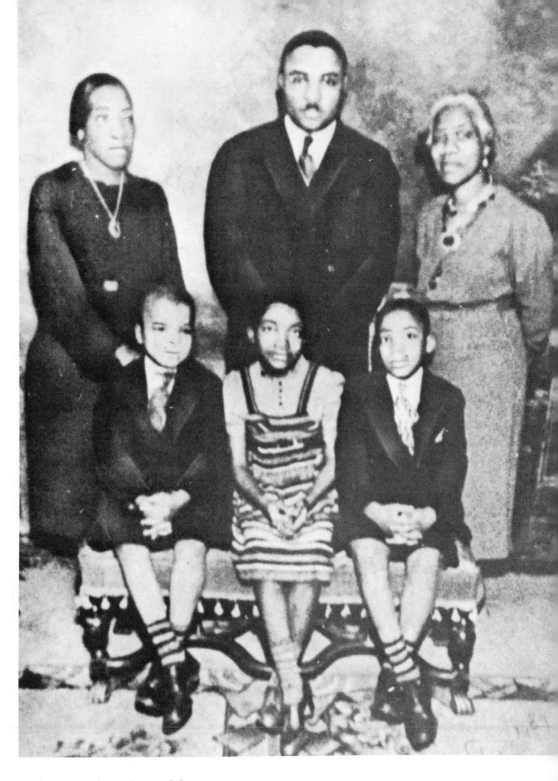

Martin Luther King
(right front) with his family

born Jan. 15, 1929, in Atlanta, Ga.

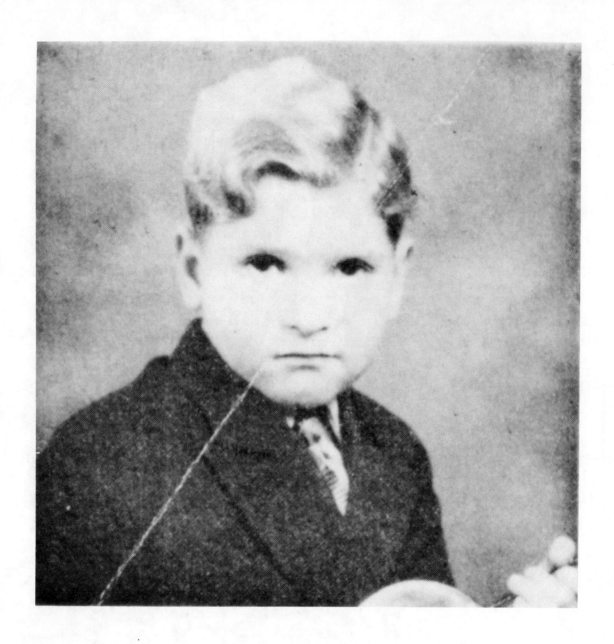

Paul Krassner
(age 6) from program of his Carnegie Hall violin recital

born April 9, 1932, in Brooklyn, N.Y.

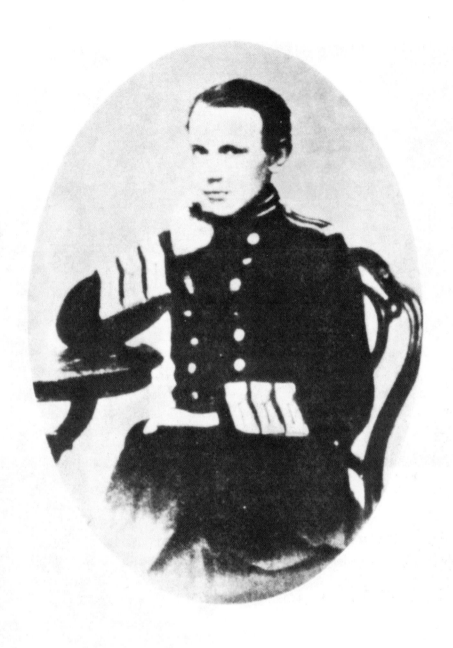

Peter Kropotkin
(about 18) in Cadet's uniform of the Czar's Corps of Pages

born Nov. 26, 1842, in Moscow

Oliver Hardy
born Jan. 18, 1892, in Harlem, Ga.

Stan Laurel
born June 16, 1890,
in Ulverston, Lancashire, England

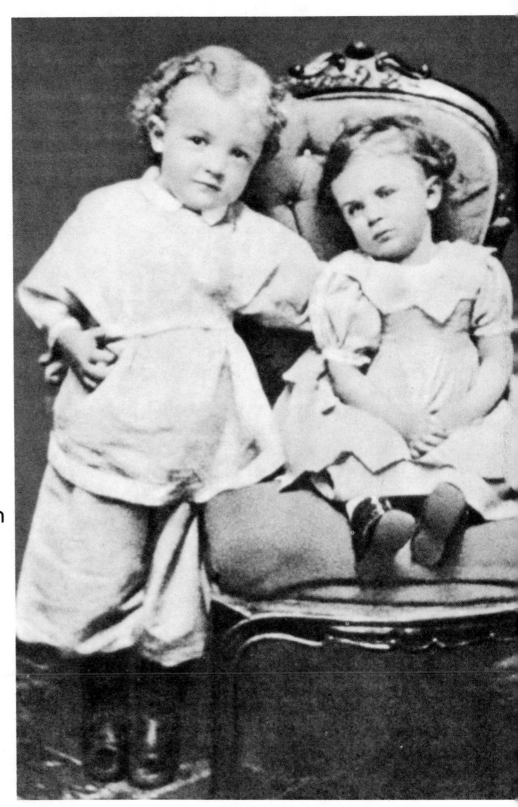

Nikolai Lenin
(age 4)
with his sister Olga

born April 22, 1870,
in Simbirsk, Russia

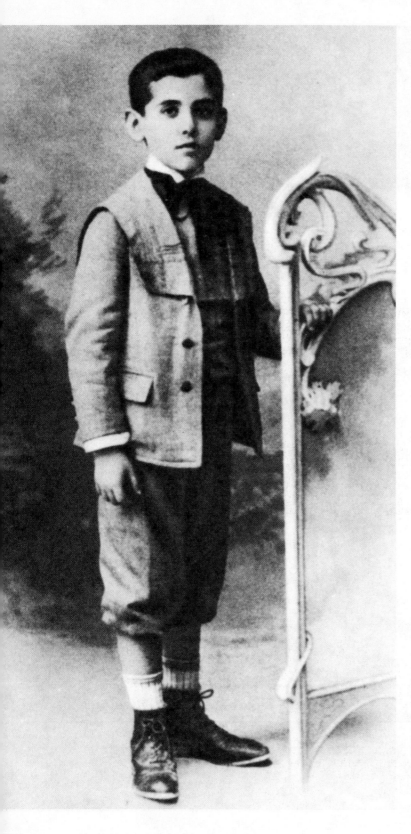

Federico García Lorca
(age 6) born June 5, 1898,
in Fuentevaqueros, Spain

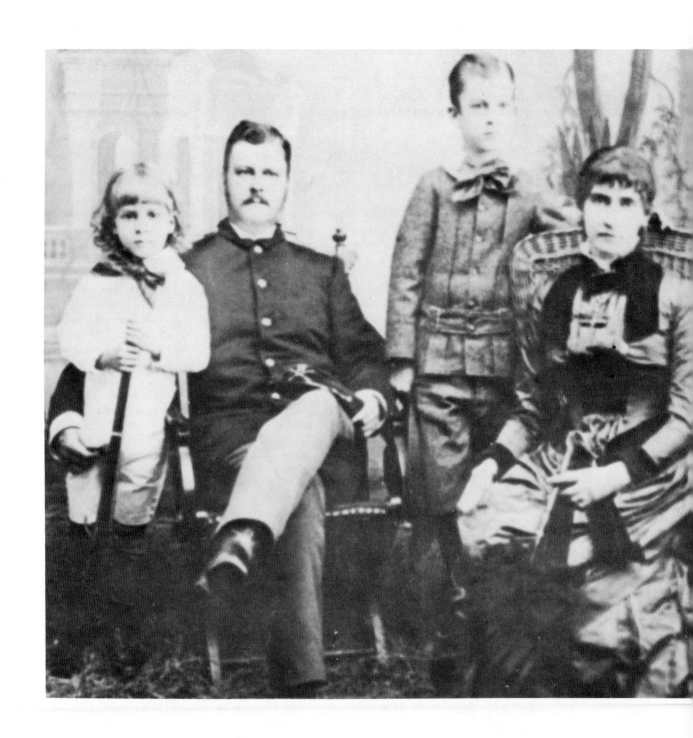

Douglas MacArthur

(left, about 2) with his brother Arthur and parents
born Jan. 26, 1880, in Little Rock, Ark.

THE MARTIAN INVASION by Norman K. Mailer [age 10], in two parts.

Wanted for court martial and murder and hated by both sides, Captain Bob Porter and Private Ben Stein played their lone hand.

Chapter XI. A Mystery

The captives were placed in a prison for several days in which they were brutally treated by their captors.

Bob had a hard time restraining his temper. It was lucky for him he didn't as they might have killed him.

The next day they were chained onto the wall in the back part of a rocket boat. Bob knew in a hazy way that they were going towards the south in which there were the best places in the city. Among them was a huge castle that was crumbling to pieces.

Bob gave a sigh of relief that they were alone. The sigh turned into a groan as a pointed piece of iron fell onto Bob's arm. Bob saw that the edge was very sharp. Putting his teeth on it he started sawing at the chains. For a half hour he sawed at it before it broke.

Bob dropped the chains and took the piece of iron

out of his sore and bleeding mouth. In an instant he was free. He then loosened the others bonds.

The captives then ranged on the front door. Bob then hit the metal door with a chain. The jailors came running over and opening the door rushed in. The Martians hadn't a chance. As each one came in he was knocked over the head until not one was left. The captives then ran through the open door locking it behind them.

They then rushed up on the pilots who met the same fate—all except one who jumping out swam towards shore.

In an instant the alarm was given and a dozen boats rushed over to easily capture the boat.

Two hours later they were again bound and guarded in a new rocket ship as the old one was demolished. They were rushed out and were herded into a small passage that led into a huge round ball building that had no windows.

They were ushered into a room where they were blindfolded and taken through so many corridors and rooms that they hadn't an inkling at the end of where they had went. Finally they were made to descend eighty steps. Bob counted them. They then were bound on their hands and arms. The guard then took a rope rolling it over them, then he fastened them to the floor with ropes.

The captives waited half an hour before they heard a thing, but when they did they wished they hadn't. A fearful laugh sounded all through the room. Then a part of the ceiling slowly began to move towards the floor. On it was a big Martian who with a big stick kept hitting it on his chair making an eerie sound.

Then to the surprise of all he said, "Welcome friends to our country." Bob gasped in amazement and the thought ran through his mind how did he know English.

The Martian reading his thoughts laughed and said, "My friend wants to know how I speak english." Bob noticed that he was purple with laughter.

Bob had noticed that the man talked with a French accent. Bob had a smattering of French so he said, "Parlez vous Francaise." The Marsian answered, "Oui, oui, mons—you dog," he shouted, "the idea."

Bob lay back choking his laughter back. The Martian sputtered in rage and threw his sceptar at him. Bob dodged it and it fell on the ground after hitting the wall.

Then he continued, "You shall die a nice death, a very nice death." The Martian again became purple. He then said, "Suffocation is nice isn't it. A slow

Norman Mailer
born Jan. 31, 1923, in Long Branch, N.J.

long drawn out death, ho, ho, ho, ho, ho." And again the monster laughed.

Bob felt an eerie chilling of his veins and his heart seemed dead. How he wished he was loose and had an electric pistol.

The Martian calmly continued, "Do not try to escape as you would never get away. You will be fed but don't be happy, you haven't a chance. As for you, you silly dumbbell who thinks he is smarter than I, you shall not get anything to eat and the jailors will do so much that you will be sorry. Remember all of you that death comes five days from now." Saying these words he left the chamber letting the captives ponder over their fate.

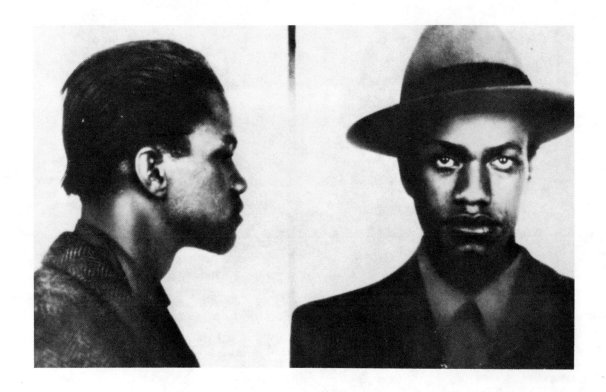

Malcolm X
(about 19)

born May 19, 1925, in Omaha, Neb.

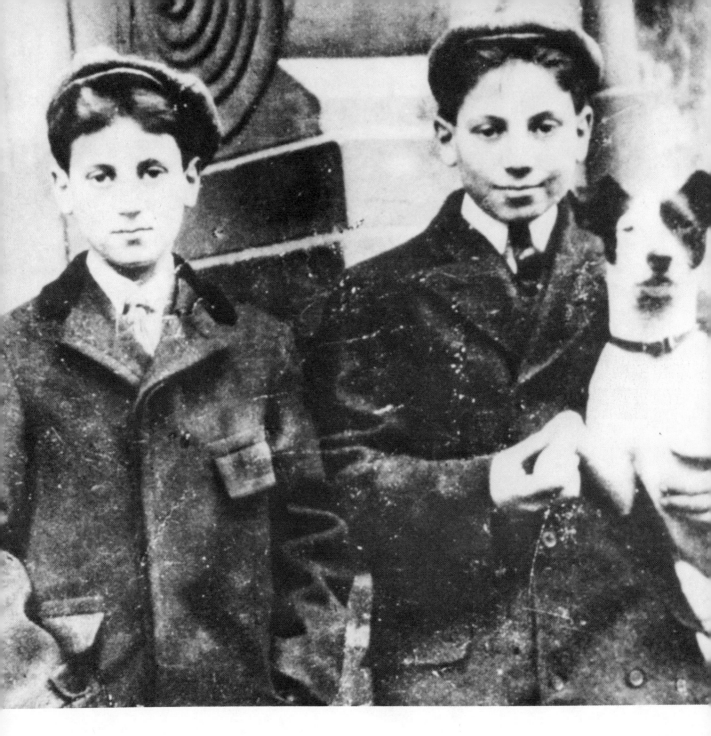

Groucho and Harpo Marx

Groucho: born Oct. 2, 1895, in New York City
Harpo: born Nov. 21, 1893, in New York City

THE PLAYER

The player strikes up on the violin,
His blond hair falling down.
He wears a sword at his side,
And a wide, wrinkled gown.

"O player, why playest thou so wild?
Why the savage look in the eyes?
Why the leaping blood, the soaring waves?
Why tearest thou thy bow to shreds?"

"I play for the sake of the thundering sea
Crashing upon the walls of the cliffs,
That my eyes be blinded and my heart burst
And my soul resound in the depths of Hell."

"O player, why tearest thou thy heart to shreds
In mockery? This art was given thee
By a shining God to elevate the mind
Into the swelling music of the starry dance."

"Look now, my blood-dark sword shall stab
Unerringly within thy soul.
God neither knows nor honors art.
The hellish vapors rise and fill the brain,

"Till I go mad and my heart is utterly changed.
See this sword—the Prince of Darkness sold it to me.
For me he beats the time and gives the signs.
Ever more boldly I play the dance of death.

"I must play darkly, I must play lightly,
Until my heart, and my violin, burst."

(about 19)

Karl Marx

born May 5, 1818, in Trier, Germany

Joe McCarthy
(right) with two brothers

born Nov. 14, 1908, on a farm in Grand Chute Township, Wisc.

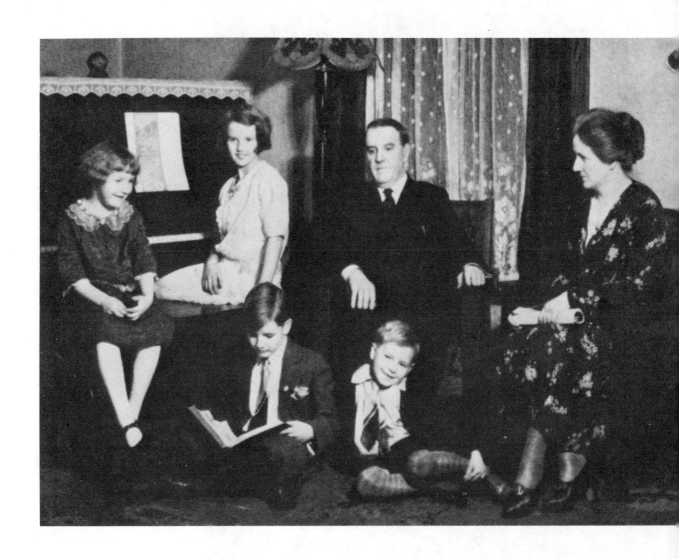

George McGovern
(reading book) with his family

born July 19, 1922, in Avon, S.D.

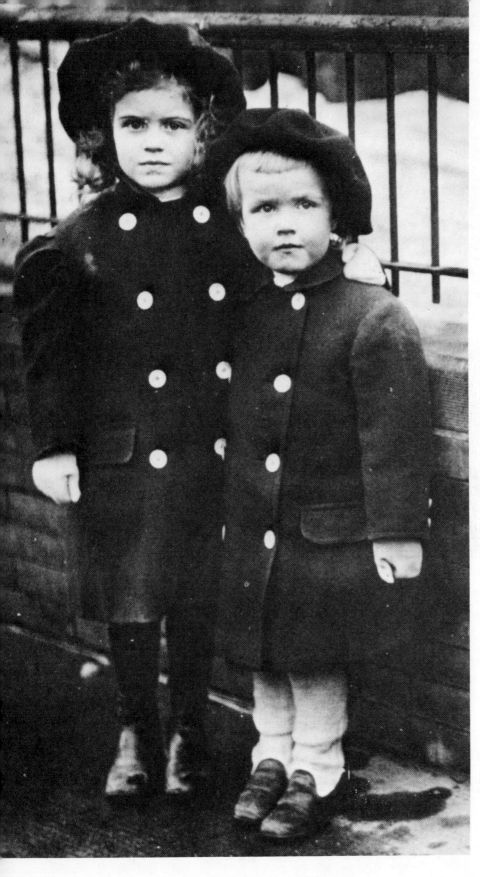

Margaret Mead
(about 5)
with her brother Richard
born Dec. 16, 1901,
in Philadelphia, Pa.

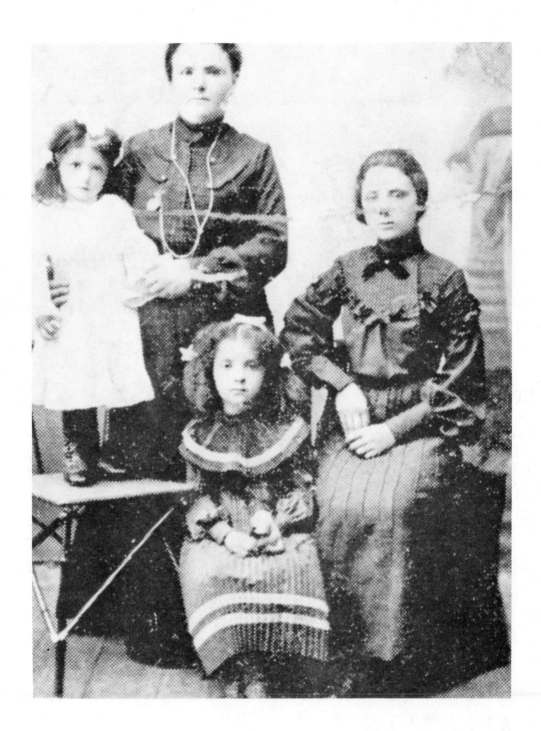

Golda Meir

(center) with her mother and two sisters

born May 3, 1898, in Kiev, Ukraine

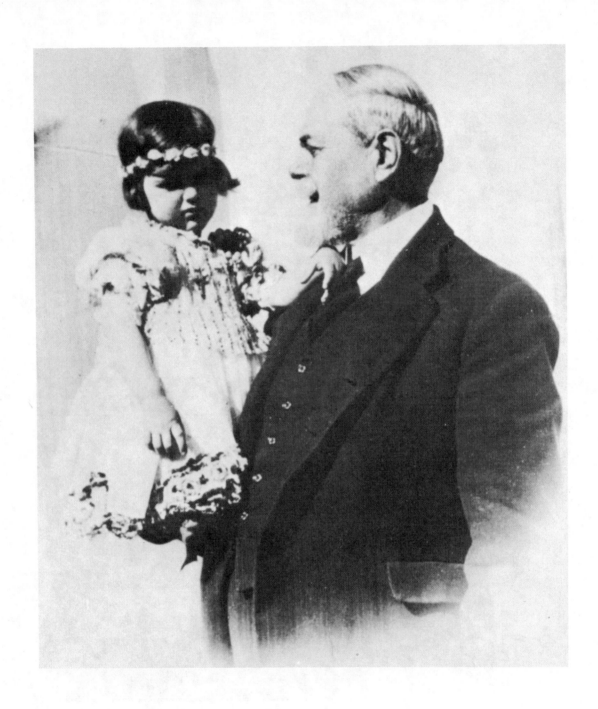

Melina Mercouri
with her grandfather Spiro, mayor of Athens for 30 years

born Oct. 18, 1925, in Athens, Greece

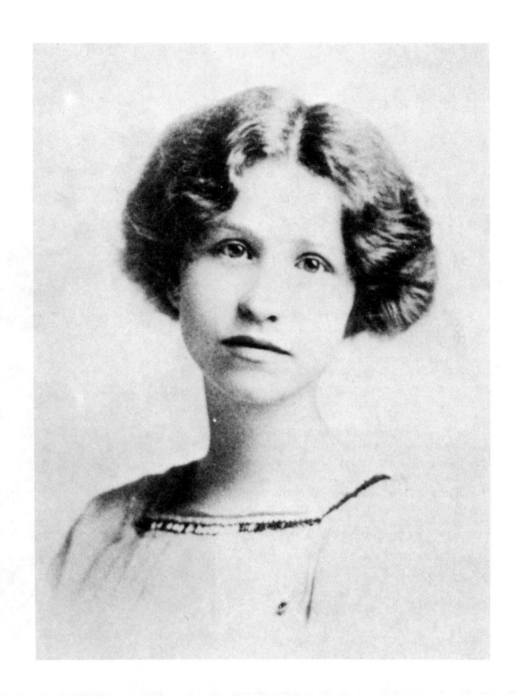

Edna St. Vincent Millay
(about 13)

born Feb. 22, 1892, in Rockland, Me.

Glendale, L. I.,
March 28, 1899.

Dear Mamma and Papa,
As it is a dreary rainy day, so I have plenty of time to write.

We went to bed last night at nine o'clock, and we did not fall to sleep untill half past ten. In the morning we got up at seven o'clock, and after break-fast we went to Minnie's school. After school I wrote this letter. Dear mamma, Mrs. Imhof would like to have you to do her a favor. If the weather is fine Wednesday, you should come for dinner with out fail, if not then come on Thursday. Mrs. Imhof, would like to go to the city while you are here, so somebody is with Gertrude.

Dear mamma you can tell Aunt Annie and Aunt Emily and Grandpapa, I sent my love on a long string from Glendale to 662 Driggs Ave. Brooklyn N.Y. and a bushel of kisses.

I will close my letter, with best regards to all, with love and lots of kisses to you, papa, and my dear little sister Lauretta. *Hoping you are all well and happy, as I am. I remaine your loving son, Henry.*

(age 7)

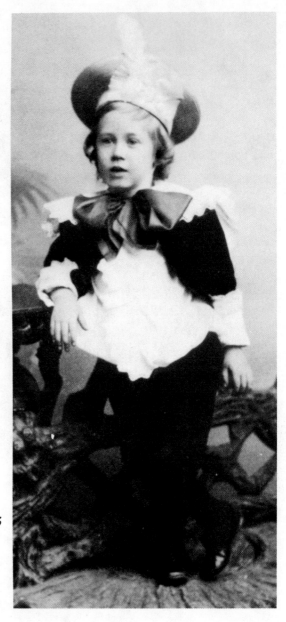

Henry Miller
(age 3½)

born Dec. 26, 1891, in New York City

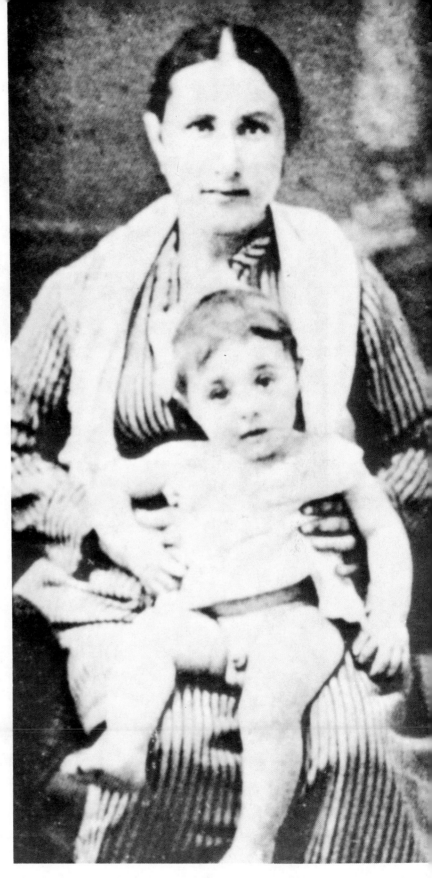

Amedeo Modigliani
with his nurse

born July 12, 1884, in Leghorn, Italy

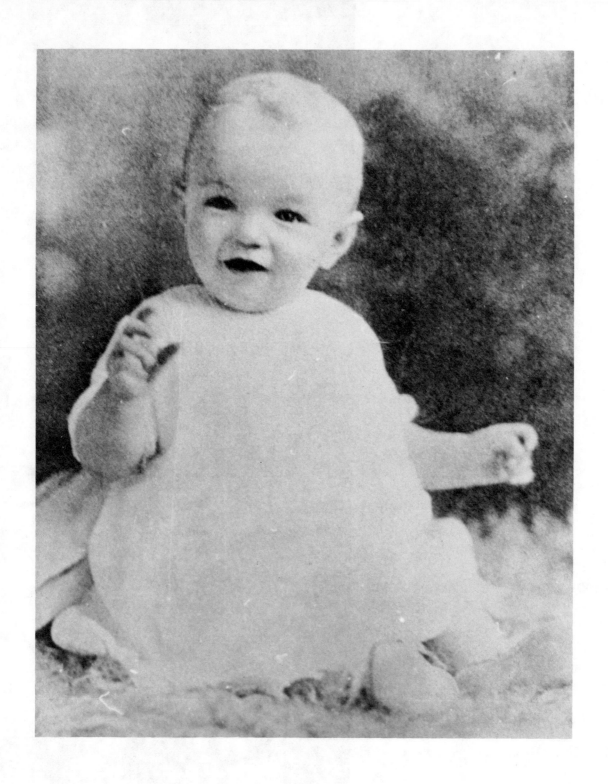

Marilyn Monroe
born June 1, 1926, in Los Angeles, Calif.

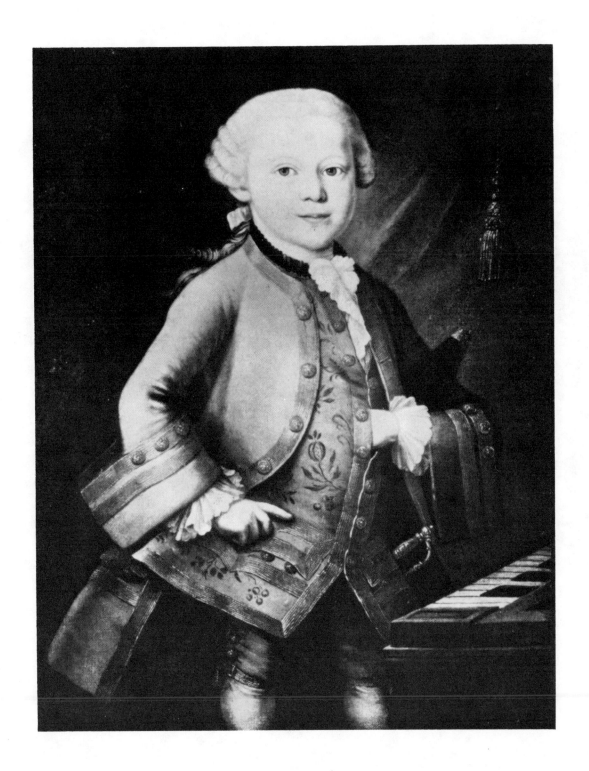

Wolfgang Amadeus Mozart
(age 6) born Jan. 27, 1756, in Salzburg, Austria

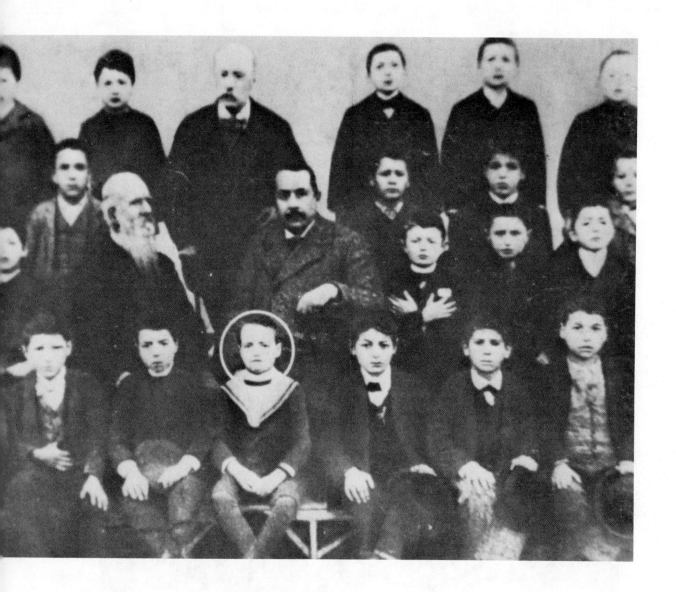

Benito Mussolini
(circled, about 8)

born July 29, 1883, in Dovia de Predappio, Forli Province, Italy

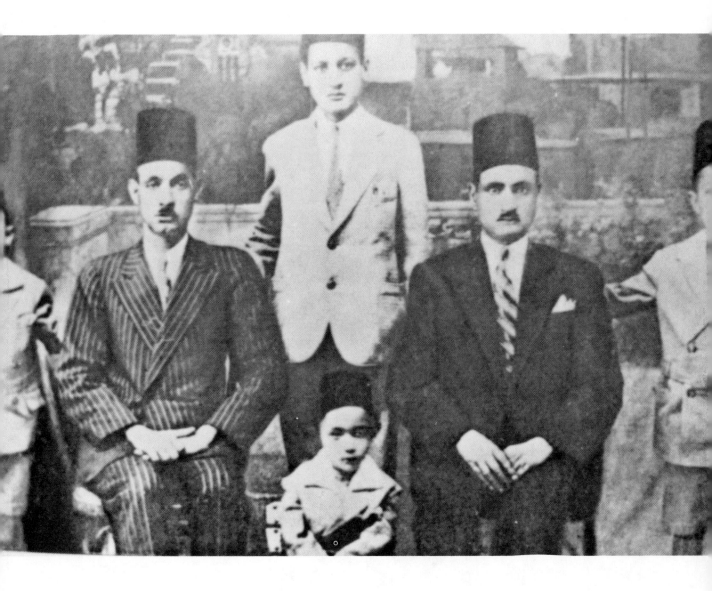

Gamal Abdel Nasser
(standing, center) with his father, uncle, and brothers

born Jan. 15, 1918, in Bacos, Alexandria, Egypt

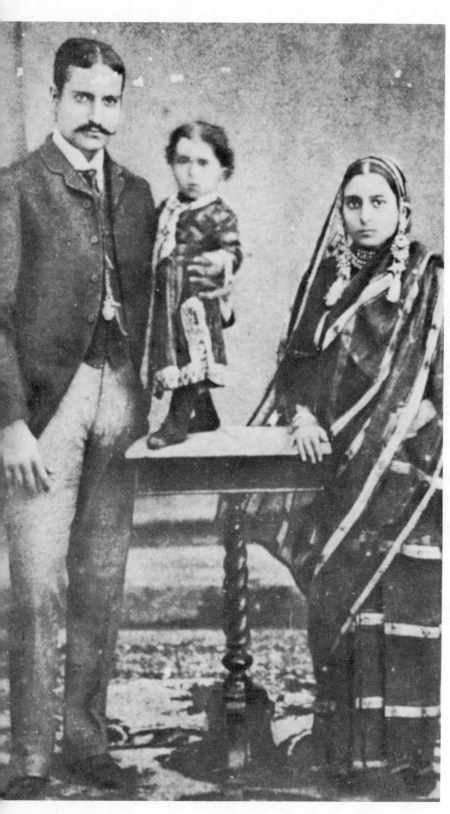

Jawaharlal Nehru
with his parents

born Nov. 14, 1889,
in Allahabad, India

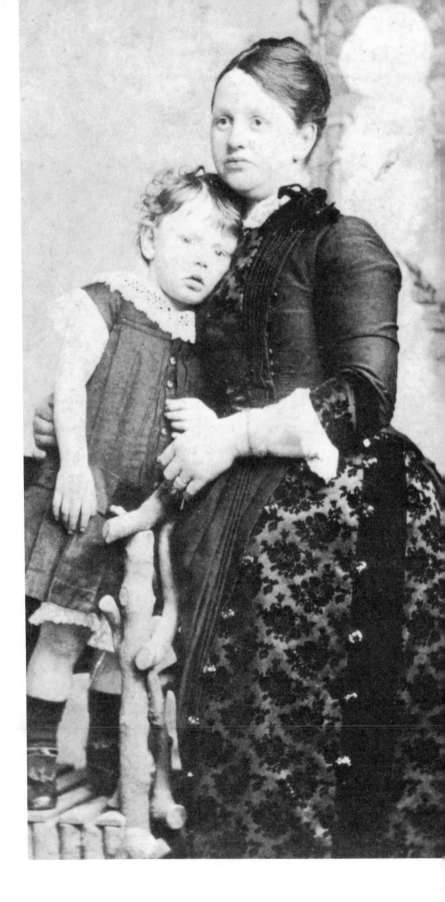

A. S. Neill
(age 3) with his mother

born Oct. 17, 1883,
in Forfar, Scotland

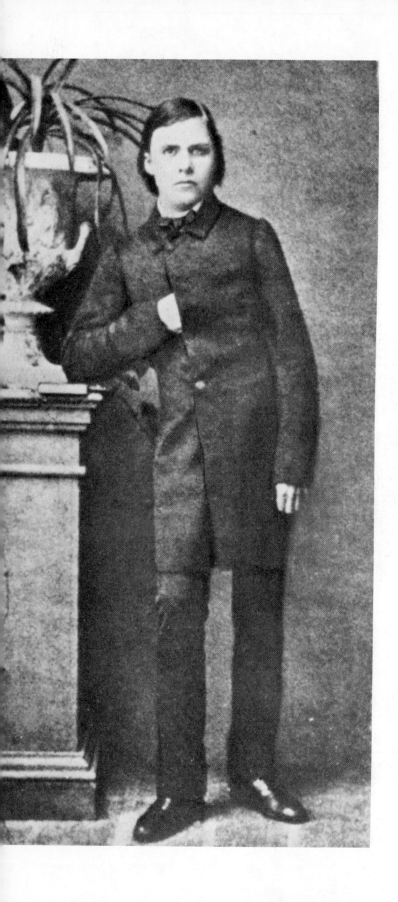

Friedrich Nietzsche
(about 16)
born Oct. 15, 1844,
in Röcken, Prussian Saxony

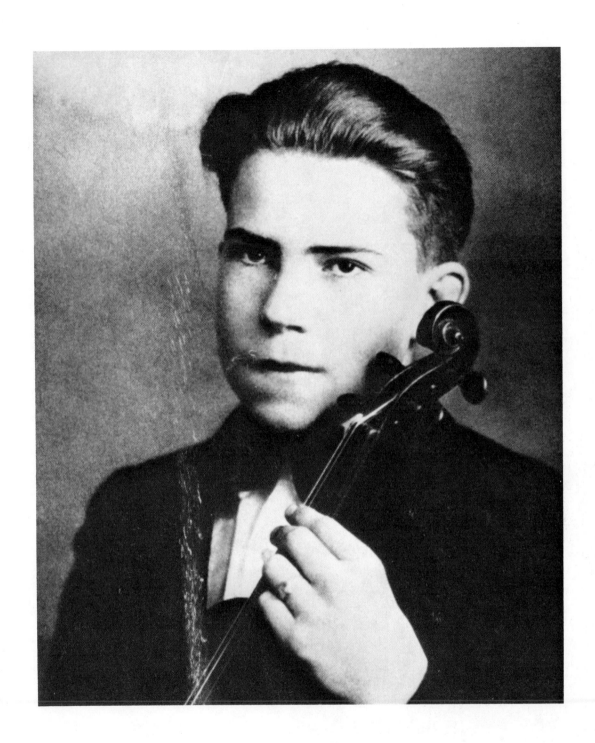

Richard Nixon
(age 14)

born Jan. 9, 1913, in Yorba Linda, Calif.

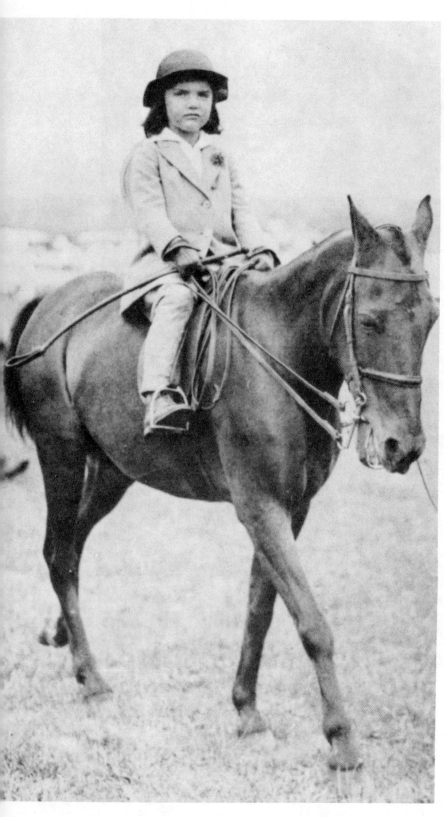

Jacqueline Onassis
(age 5)
in horse show competition

born July 28, 1929,
in Southampton, L.I., N.Y.

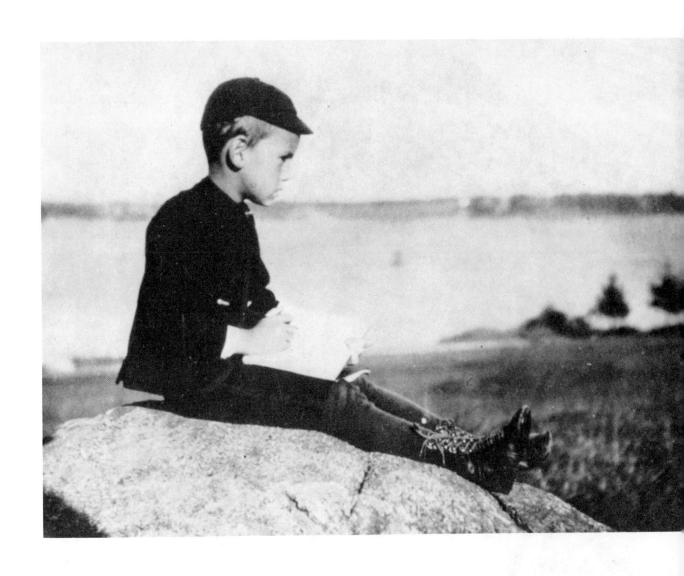

Eugene O'Neill

born Oct. 16, 1888, in New York City

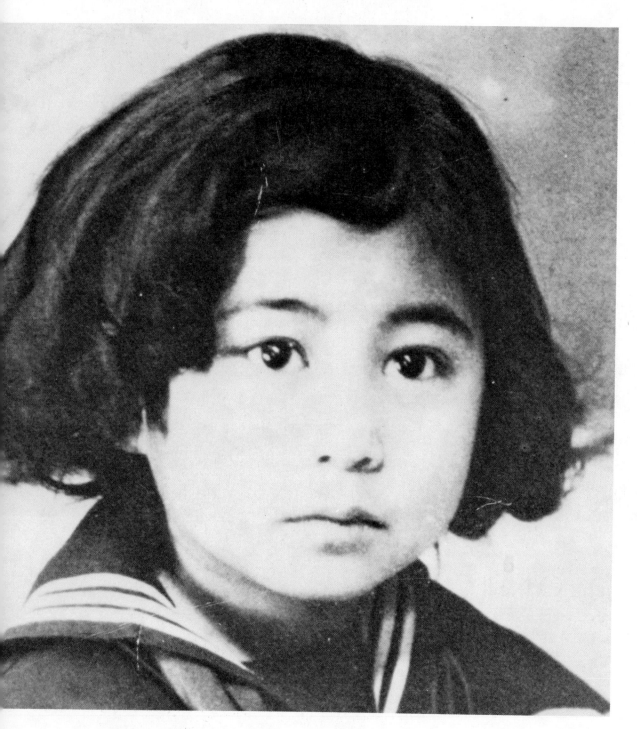

Yoko Ono

born Feb. 18, 1933, in Tokyo, Japan

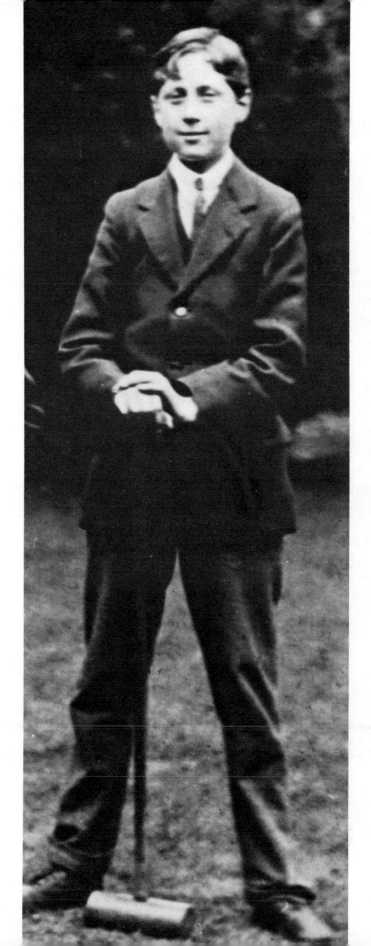

George Orwell
(age 14)
born June 25, 1903,
in Motihari, Bengal, India

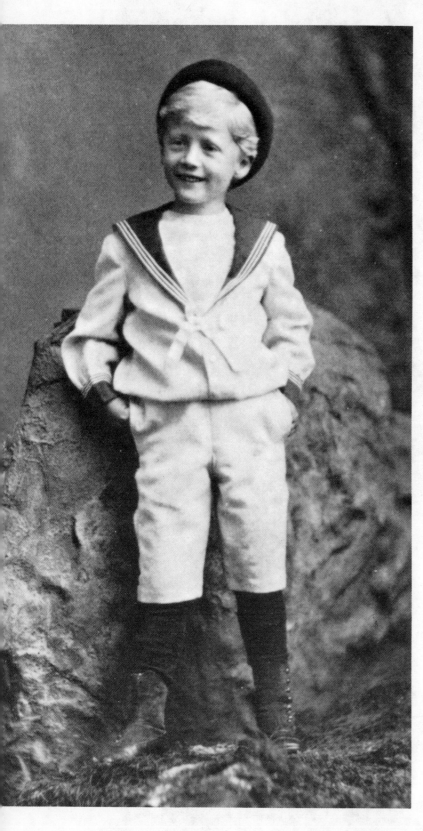

George S. Patton, Jr.
(about 6)

born Nov. 11, 1885,
in San Gabriel, Calif.

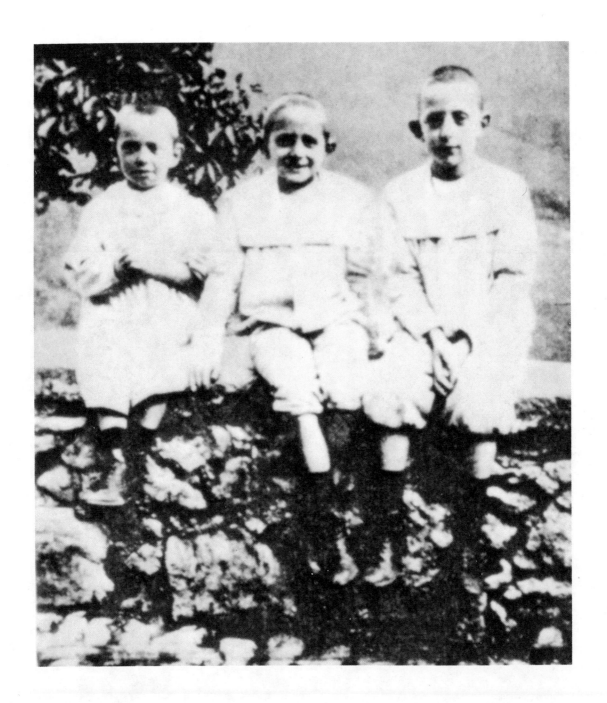

Pope Paul VI
(Giovanni Battista Montini) (center) with his brothers

born Sept. 26, 1897, in Concesio, Brescia, Italy

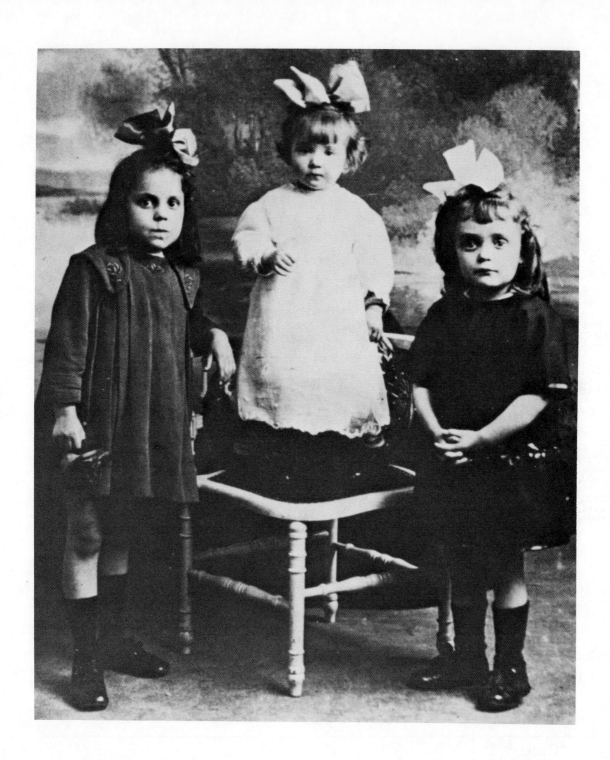

Edith Piaf
(right, age 4)
born Dec. 19, 1915, in Paris, France

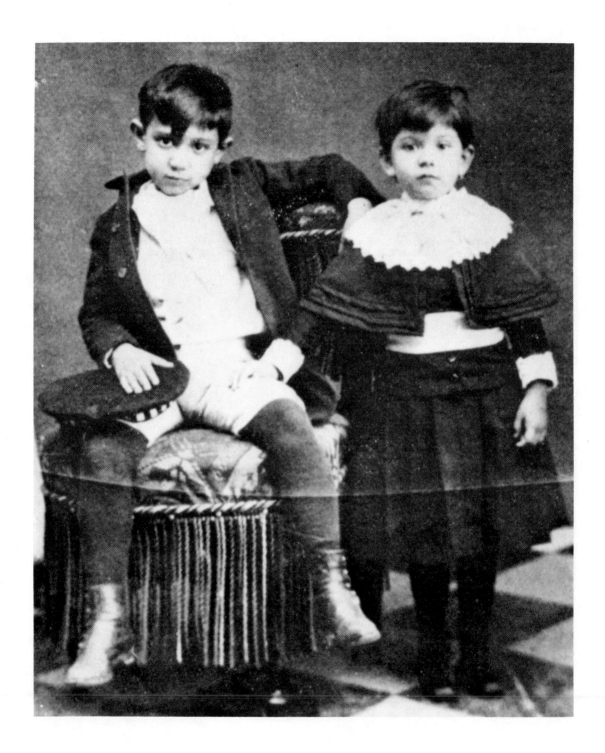

Pablo Picasso
with his sister Lola
born Oct. 25, 1881, in Málaga, Spain

Ezra Pound
(about 12) at Cheltenham Military Academy
born Oct. 30, 1884, in Hailey, Idaho

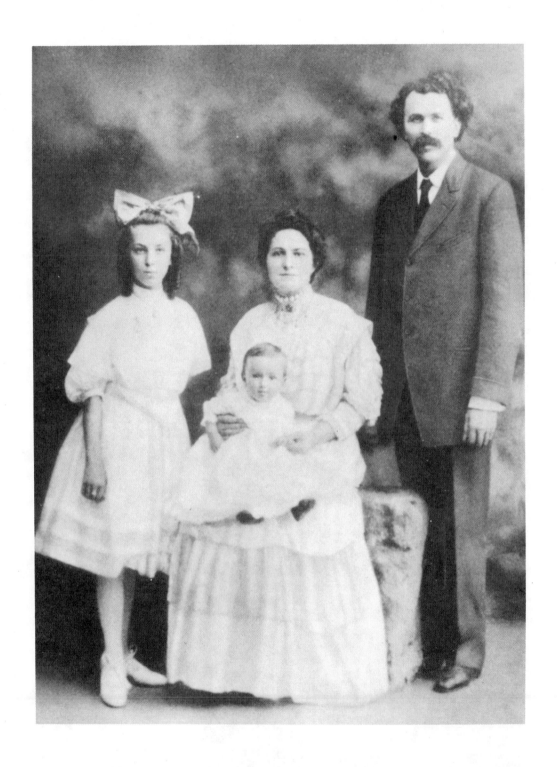

Adam Clayton Powell, Jr.

(age 3 months) with his family
born Nov. 29, 1908, in New Haven, Conn.

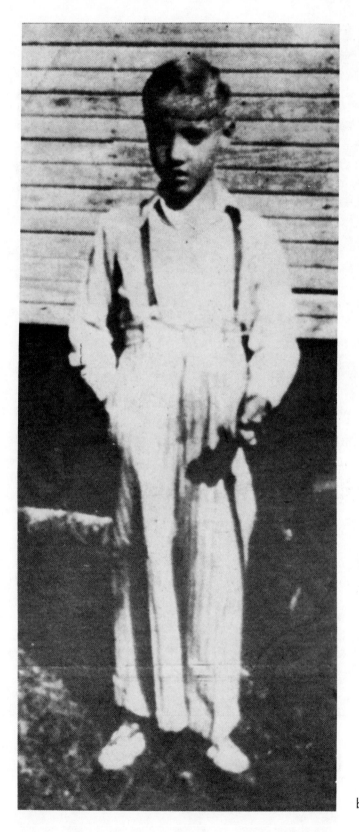

Elvis Presley
(age 4)
born Jan. 8, 1935, in Tupelo, Miss.

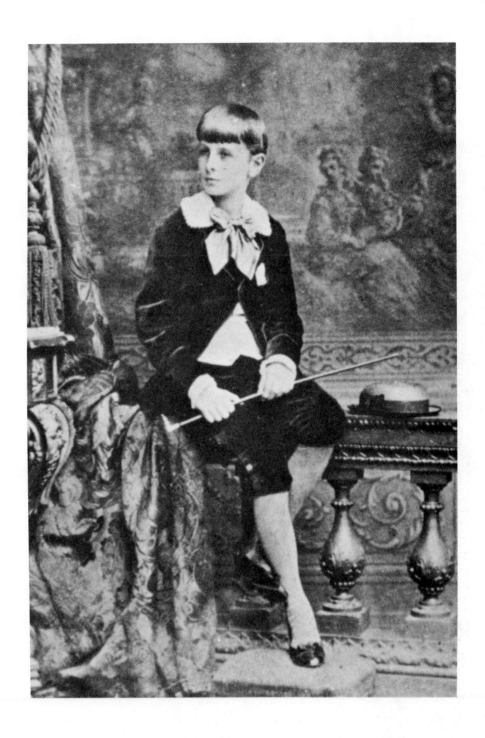

Marcel Proust
(age 12)
born July 10, 1871, in Paris, France

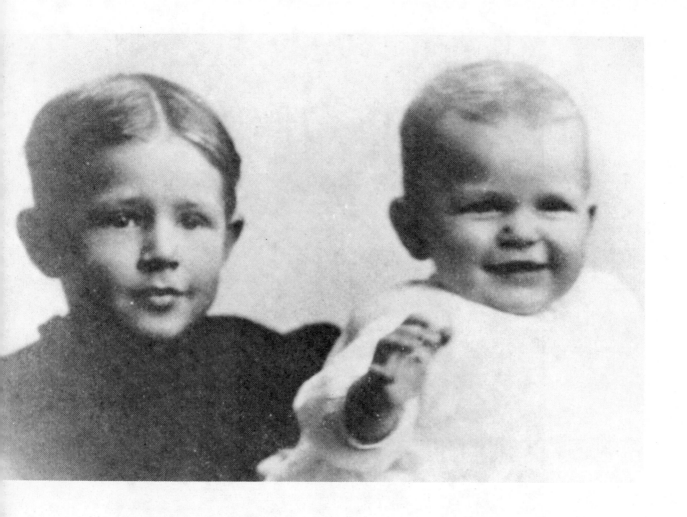

Ronald Reagan
(right) with his brother Neil

born Feb. 6, 1911, in Tampico, Ill.

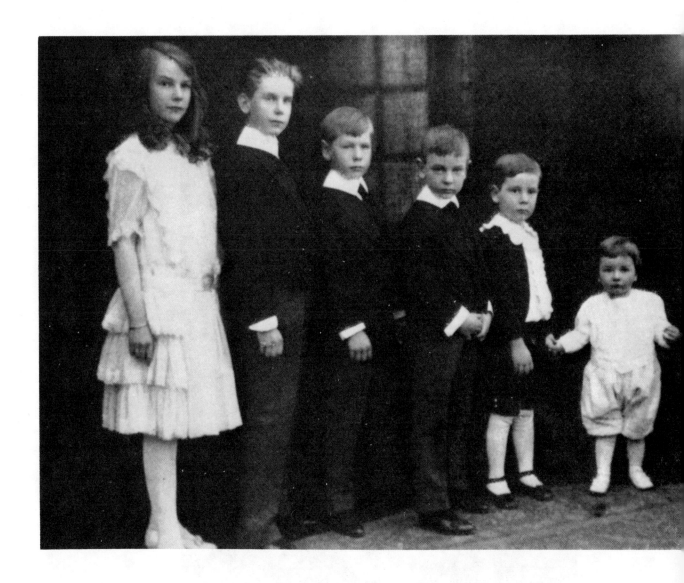

The Rockefellers: Abby, John 3rd, Nelson,
Laurance, Winthrop, and David

John: born March 21, 1906, in New York City
Nelson: born July 8, 1908, on Mount Desert Island, Me.
Laurance: born May 26, 1910, in New York City
Winthrop: born May 1, 1912, in New York City
David: born June 12, 1915, in New York City

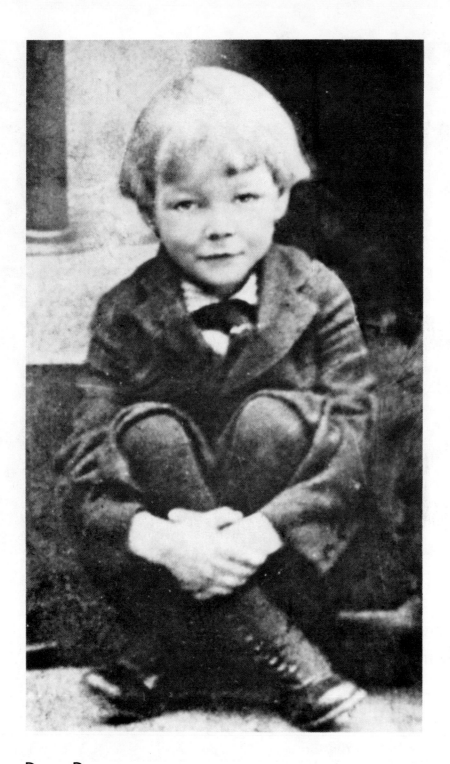

Roy Rogers
(age 5)
born Nov. 5, 1912, in Cincinnati, Ohio

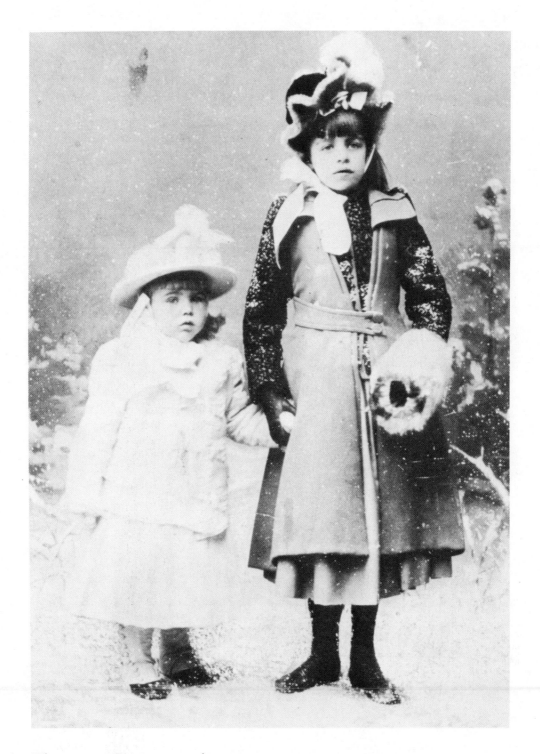

Eleanor Roosevelt
(age 7) with her brother Elliott, Jr.
born Oct. 11, 1884, in New York City

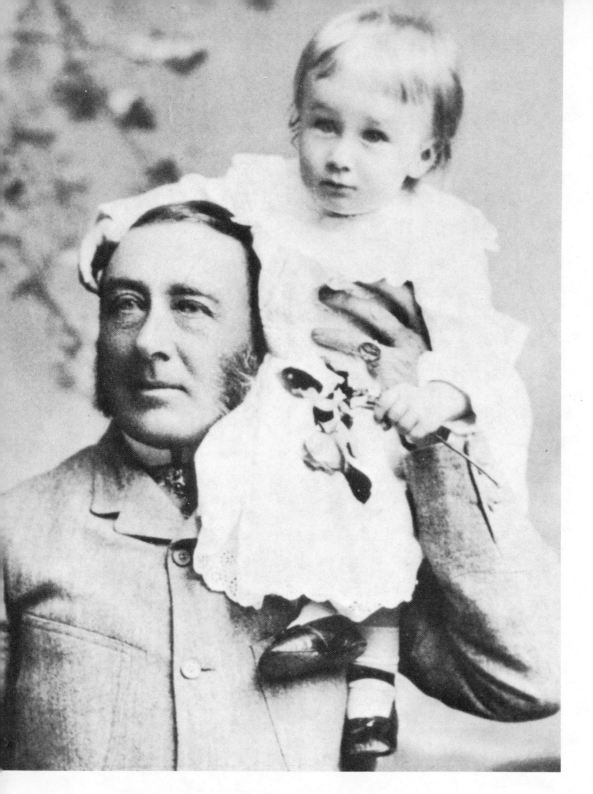

Franklin Delano Roosevelt
with his father
born Jan. 30, 1882, in Hyde Park, N.Y.

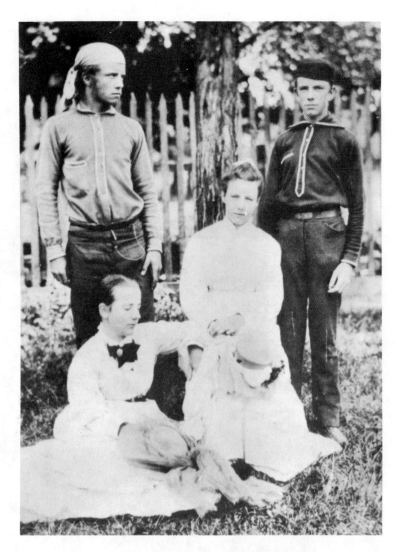

New York, April 28, 1868

My Dear Mama,

I have received your letter! What an excitement! How nice to read it. What long letters you do write. I don't see how you can write them. My mouth opened wide with astonishment when I heard how many flowers were sent in to you. I could revel in the buggie ones. I jumped with delight when I found you had heard a mocking bird. Get some of its feathers if you can. . . .

(age 10)

Teddy Roosevelt
(left) with Corinne Roosevelt, Edith Carow, Elliott Roosevelt
born Oct. 27, 1858, in New York City

Jerry Rubin

born July 14, 1938, in Cincinnati, Ohio

Bertrand Russell

(age 4) born May 18, 1872,
in Ravenscroft,
Monmouthshire, England

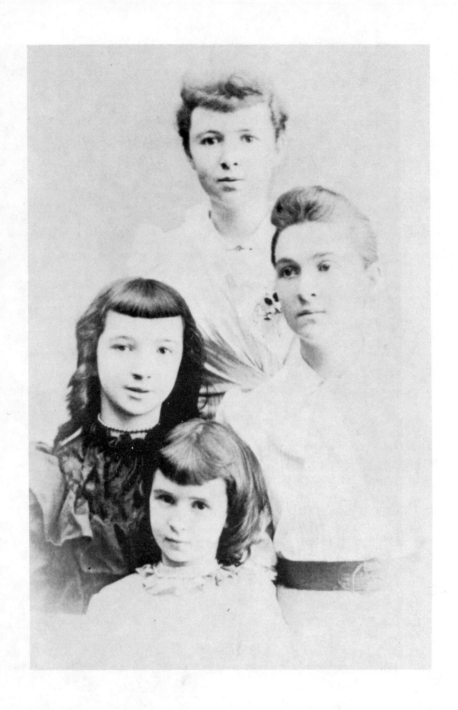

Margaret Sanger

(left) with her sisters, Ethel and Nan, and Mary Higgins

born Sept. 14, 1883, in Corning, N.Y.

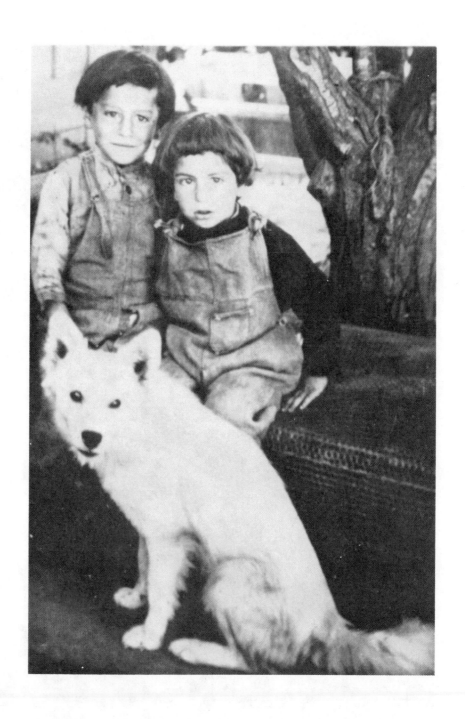

William Saroyan
(right, age 3) with his brother Henry

born Aug. 31, 1908, in Fresno, Calif.

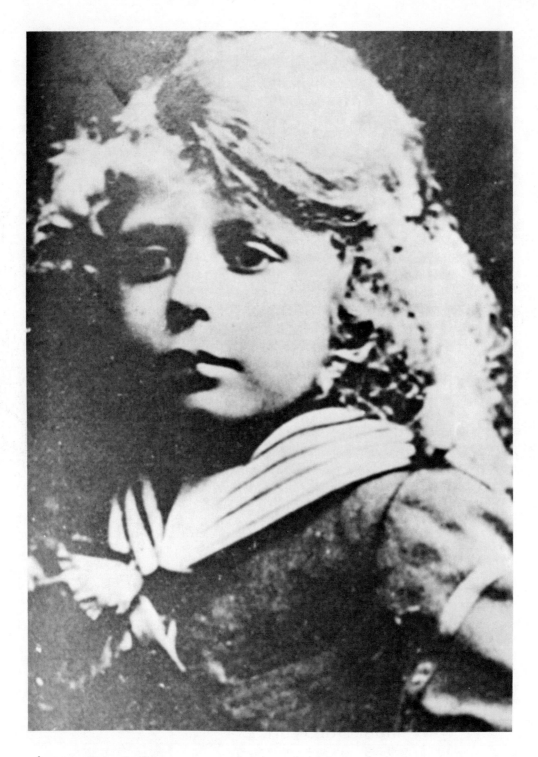

Jean-Paul Sartre

born June 21, 1905, in Paris, France

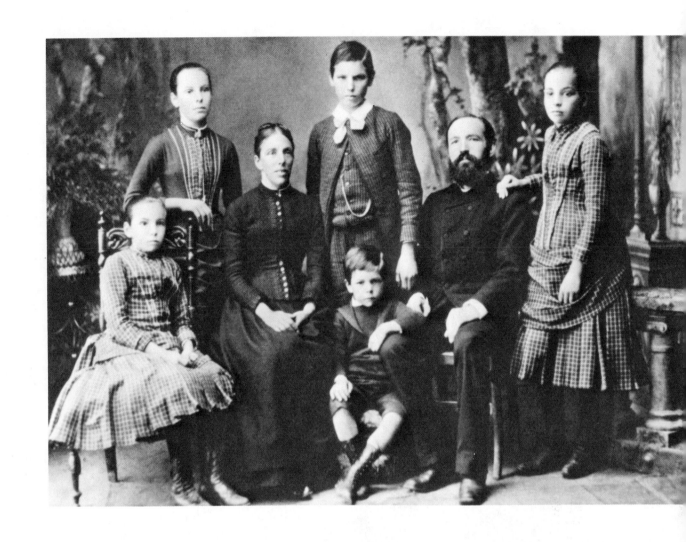

Albert Schweitzer
(standing, center) with his family
born Jan. 14, 1875, in Kaiserberg, Alsace

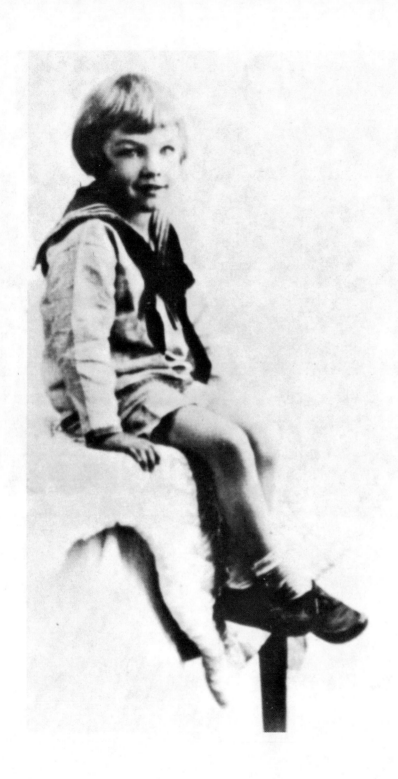

Pete Seeger
born May 3, 1919, in New York City

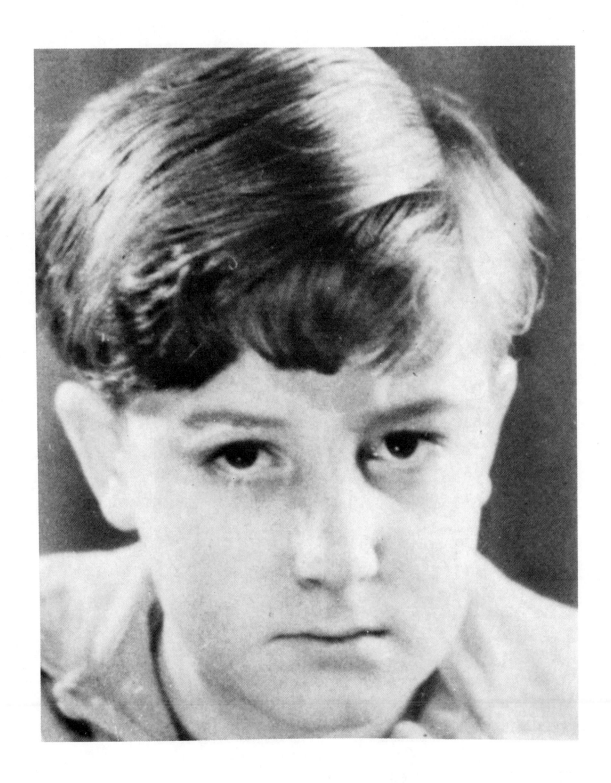

Peter Sellers
born Sept. 8, 1925, in Southsea, England

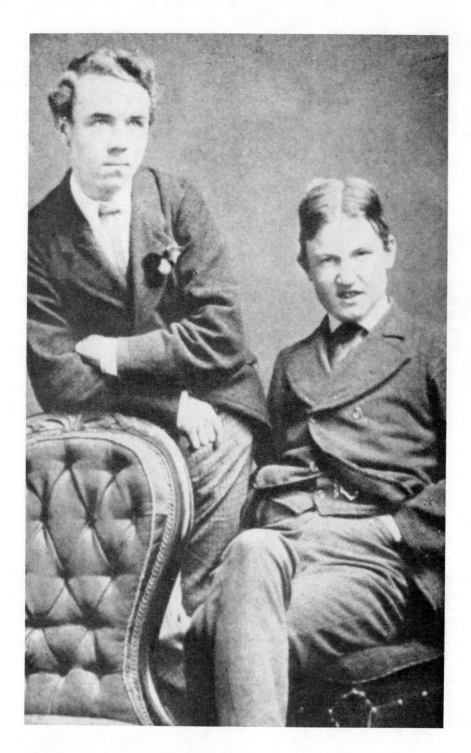

George Bernard Shaw
(right, about 17) with Matthew McNulty
born July 26, 1856, in Dublin, Ireland

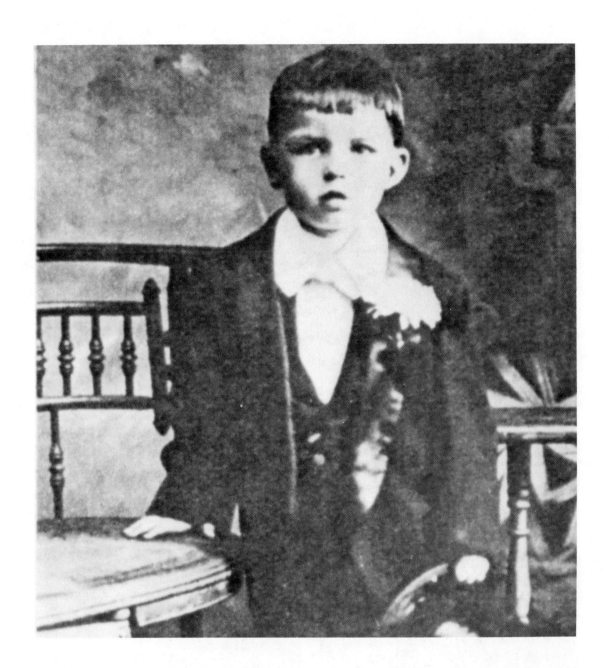

Frank Sinatra
(age 3)

born Dec. 12, 1917, in Hoboken, N.J.

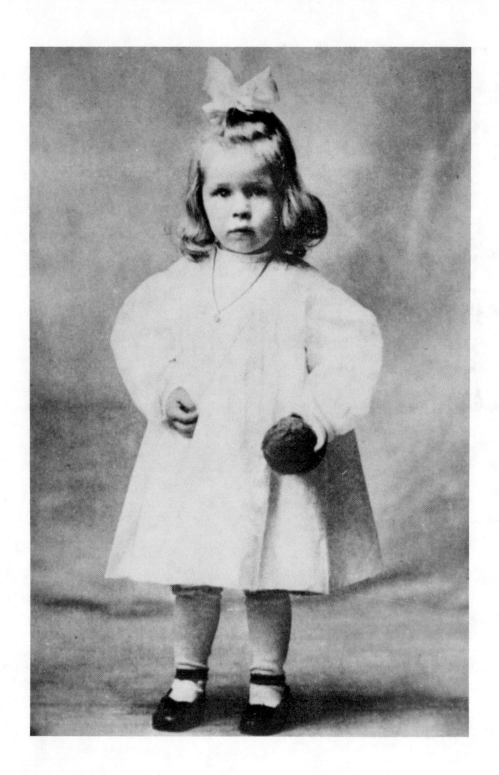

Kate Smith
(age 3) born May 1, 1909, in Greenville, Va.

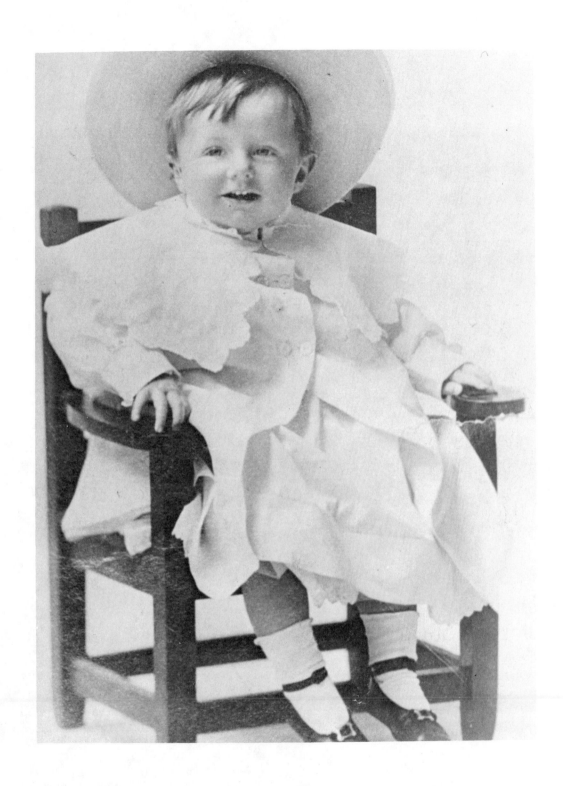

Benjamin Spock
born May 2, 1903, in New Haven, Conn.

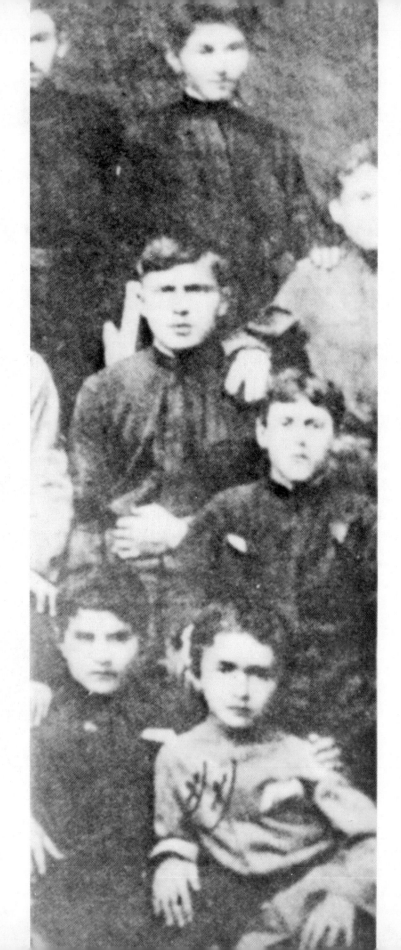

Joseph Stalin

(lower right)
with schoolchildren

born Dec. 21, 1879,
in Gori, Georgia, Caucasus

Gertrude Stein
(age 4)

born Feb. 3, 1874,
in Allegheny, Pa.

Elizabeth Taylor
(age 4)

born Feb. 27, 1932, in London, England

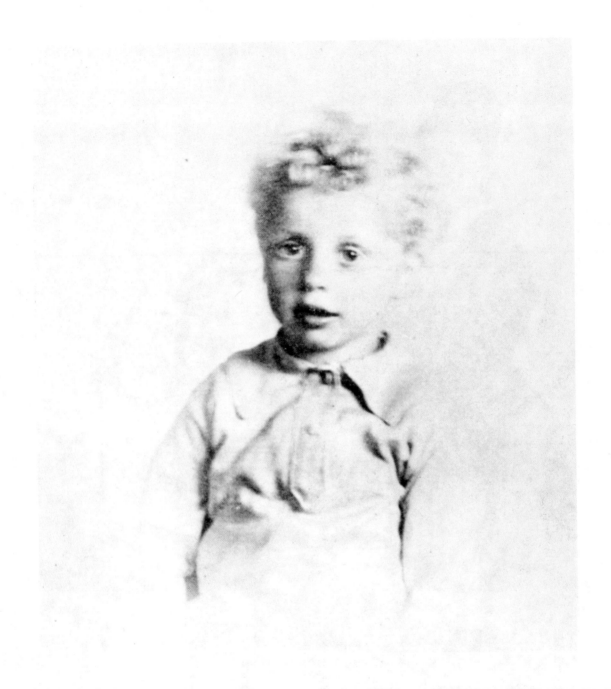

Dylan Thomas

born Oct. 27, 1914, in Carmarthenshire, Wales

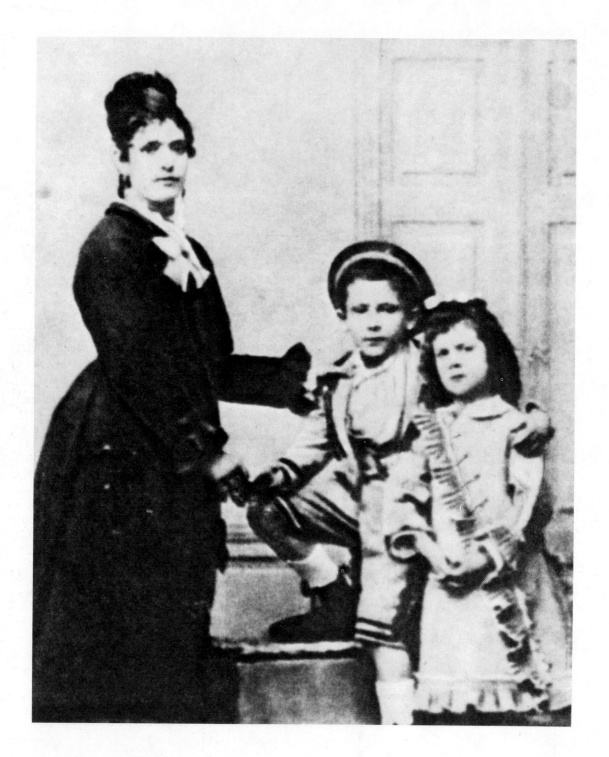

Arturo Toscanini
(age 8) with his aunt and sister
born March 25, 1867, in Parma, Italy

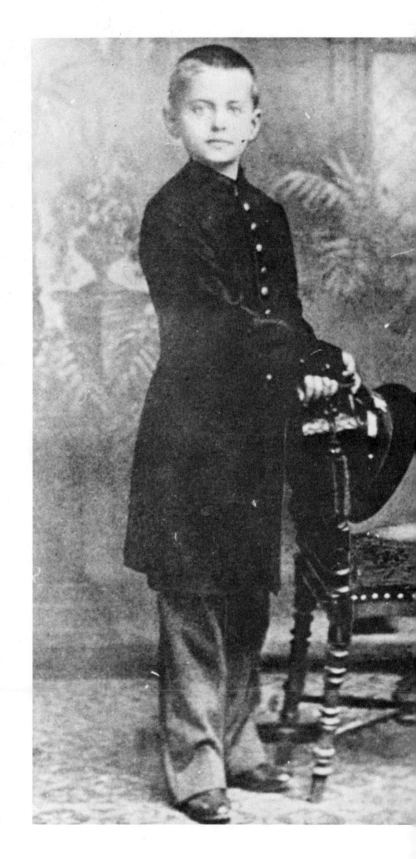

Leon Trotsky

(age 11) born Nov. 7, 1879,
in Yanovka, Kherson Province, Ukraine

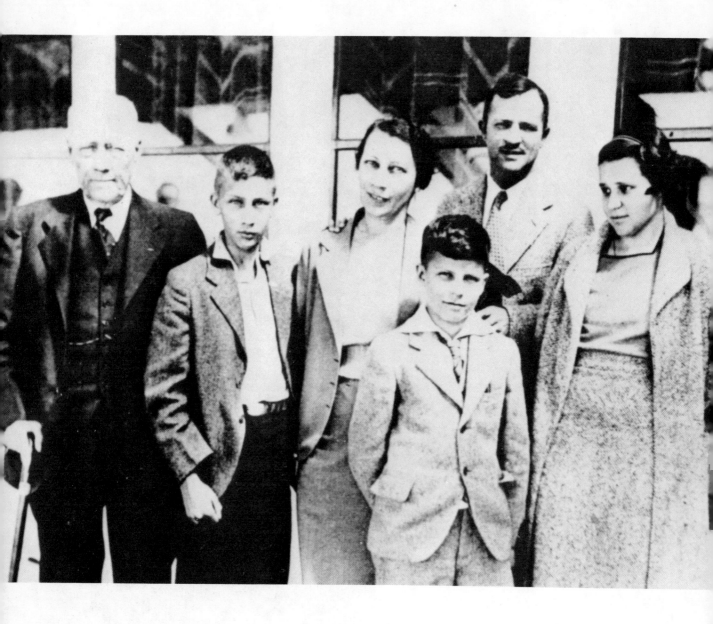

Pierre Elliott Trudeau
(second from left) with his family

born Oct. 8, 1919, in Montreal, Canada

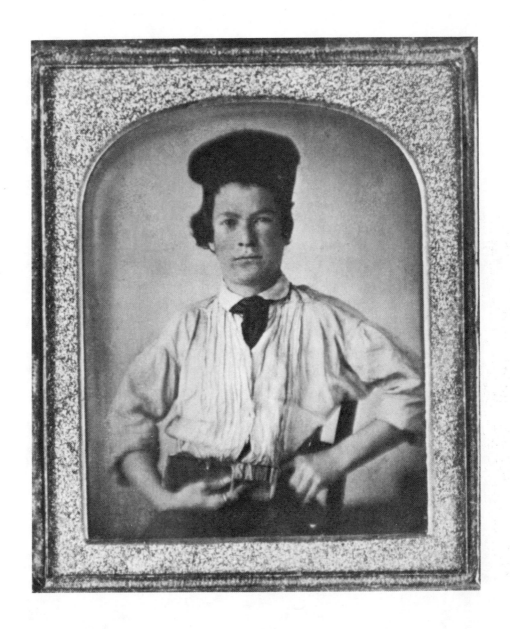

Mark Twain

(age 15) as a printer's apprentice

born Nov. 30, 1835, in Florida, Mo.

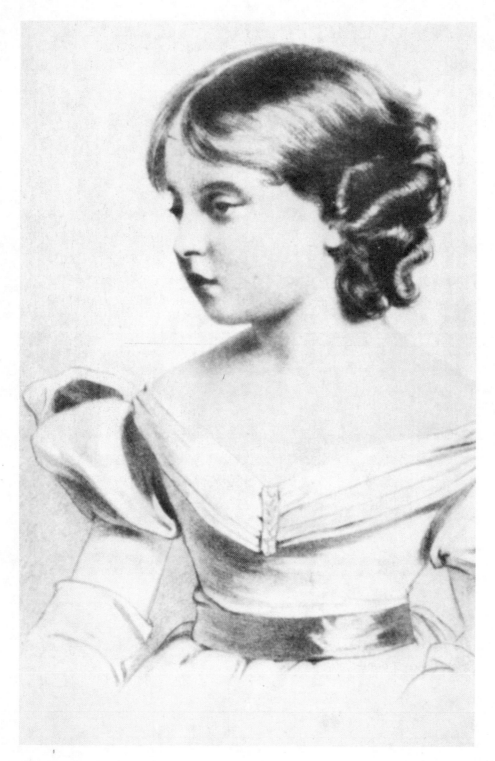

Queen Victoria
(age 10) born May 24, 1819, in Kensington Palace, London, England

George Wallace
with his mother

born Aug. 25, 1919, in Clio, Ala.

John Wayne
born May 26, 1907, in Winterset, Iowa

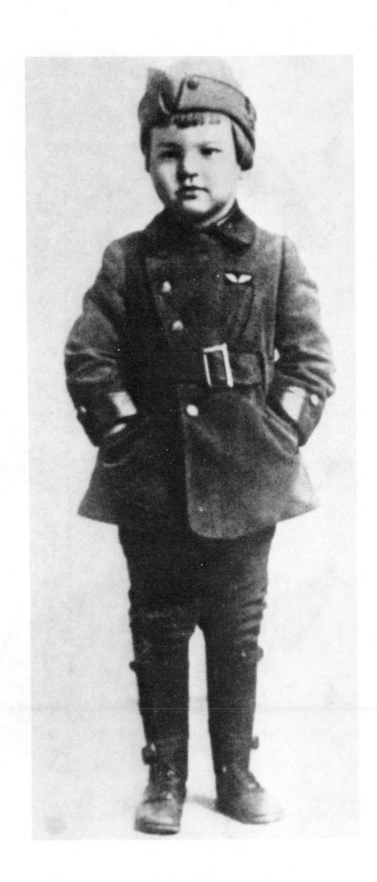

Orson Welles

(age 3) born May 6, 1915,
in Kenosha, Wisc.

Mae West
(age 6 months) born Aug. 17, 1892, in Brooklyn, N.Y.

Oscar Wilde
born Oct. 16, 1854, in Dublin, Ireland

Frank Zappa
(age 1½)

born Dec. 21, 1940,
in Baltimore, Md.

How sweet I roam'd from field to field
And tasted all the summer's pride,
Till I the Prince of Love beheld
Who in the sunny beams did glide!

He show'd me lilies for my hair,
And blushing roses for my brow;
He led me through his gardens fair
Where all his golden pleasures grow.

With sweet May dews my wings were wet,
And Phoebus fir'd my vocal rage;
He caught me in his silken net,
And shut me in his golden cage.

He loves to sit and hear me sing,
Then, laughing, sports and plays with me;
Then stretches out my golden wing,
And mocks my loss of liberty.

William Blake, before age 14

Credits

Allied Artists, O. N. Anderson, Bill Andrews, ANSA, Arbetarrorelsens Arkiv, *Artists Quarterly*, Birth Press, Uli Boege, Wallace D. Bonner, British Information Services Ottawa, Howard Brock, Guinever Buddicom, Karen Byers, Billy Joe Camp, Center for Cuban Studies, Michel Choquette, Columbia University Libraries, Detroit Police Department, Carolyn Dorsett, Claudia Dreifus, E. P. Dutton & Co., Carol Fein, John Fisk, Franklin Delano Roosevelt Library, Free Library of Philadelphia, Bill French, Paul Galer, Bernie Gelb, Ursula Hacker-Merseburger, Harvard University Libraries, Pauline Henderson, Hullmandel, International News, Gerri Johnson, Tamara Kahana (Aleichem translation), Lannes Kenfield, Richard Lane, Sandra Levinson, Liverpool Constabulary, Los Angeles *Times*, Fanny Mailer, Roger Martin, Metropolitan Toronto Public Libraries, Jean Morrison, Joelle Morrison, Danny Moses, Museum of Modern Art NYC, National Design Institute India, New York Public Library, New York University Libraries, Robert Payne (Marx translation), *The People*, Charles Roman, Lillian Roxon, Dave Ryan (photo this page), Salzburg Mozarteum, Lois Smith, Mark Spector, Sumati Morarjee Collection, N. Taylor, Tulane University Libraries, Ullstein Bilderdienst, University Place Bookshop, UPI, Vassar College Library, Deide Walker, A. J. Weberman, Jean Wickstrom, Wide World, Lois Woodyatt, Yale University Libraries, Howard Zucker.